Received On

NOV --2015

Magnolia Library

D0604462

NO LONGER PROPERTY OF
SEATTLE PUBLIC LIBRARY

TWO

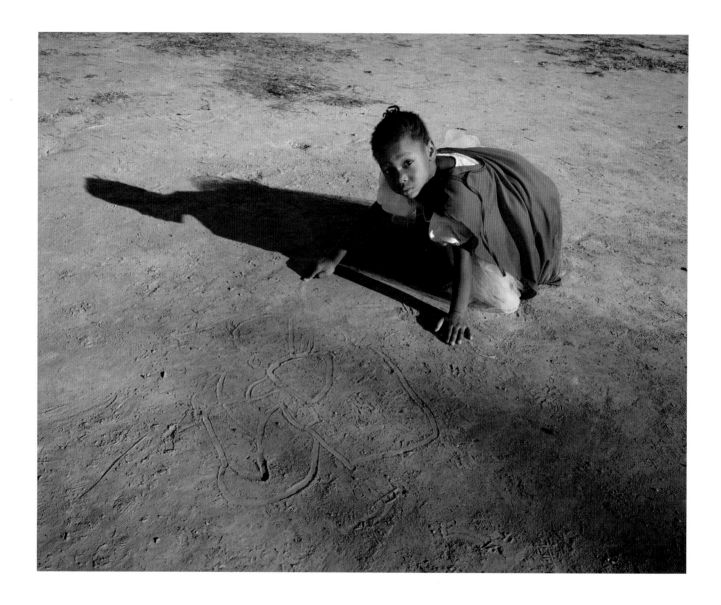

TWO

Photographs by **MELISSA ANN PINNEY** Introduction and edited by **ANN PATCHETT**

With contributions by

BILLY COLLINS · EDWIDGE DANTICAT · ELIZABETH GILBERT · ALLAN GURGANUS · JANE HAMILTON
BARBARA KINGSOLVER · ELIZABETH McCRACKEN · MAILE MELOY · SUSAN ORLEAN · RICHARD RUSSO

HARPER
DESIGN
An Imprint of HarperCollinsPublishers

TWO

Copyright © 2015 by Melissa Ann Pinney

Introduction copyright © 2015 Ann Patchett

"Two Creatures" © 2015 Billy Collins; "Two Hands and Two Feet" © 2015 Edwidge Danticat; "Two Heads on a Pike" © 2015 Elizabeth Gilbert; "THEN ONe VanisheS" © 2015 Allan Gurganus; "Aren't We a Pair" © 2015 Jane Hamilton; "The Pair" © 2015 Barbara Kingsolver; "The Dollies" © 2015 Elizabeth McCracken; "70 x 2" © 2015 Maile Meloy; "Beauty and Tookie" © 2015 Susan Orlean; "Strategy" © 2015 Richard Russo.

All rights reserved. No part of this book may be used or reproduced in any manner whatsoever without written permission except in the case of brief quotations embodied in critical articles and reviews. For information address Harper Design, 195 Broadway, New York, NY 10007.

HarperCollins books may be purchased for educational, business, or sales promotional use. For information please e-mail the Special Markets Department at SPsales@harpercollins.com.

First published in 2015 by
Harper Design
An Imprint of HarperCollins *Publishers*
195 Broadway
New York, NY 10007
Tel: (212) 207-7000
Fax: (855) 746-6023
harperdesign@harpercollins.com
www.hc.com

Distributed throughout the world by
HarperCollins *Publishers*
195 Broadway
New York, NY 10007

ISBN 978-0-06-233442-8

Library of Congress Control Number: 2013953419

Book design by: Stislow Design

Printed in China
First Printing, 2015

For Slim

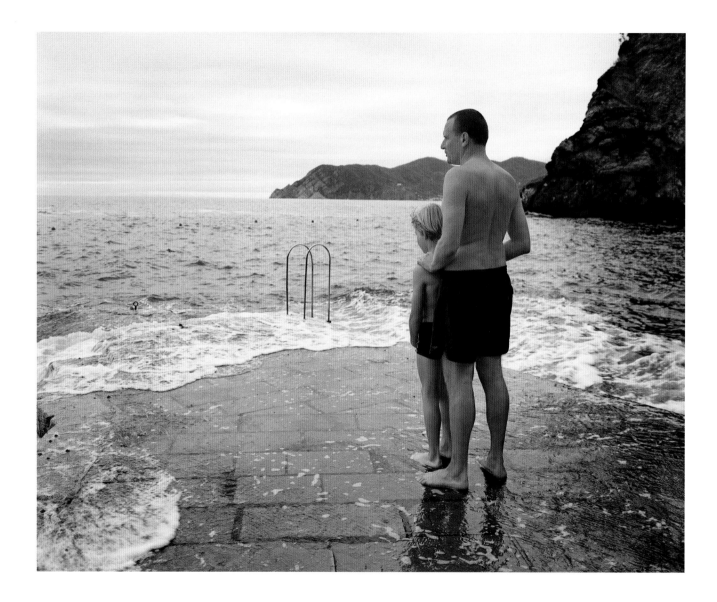

CONTENTS

PREFACE

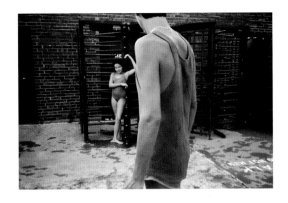

I've always been interested in watching people together. I wonder what their story is, who they are to each other.

My mother was acutely aware of other people and she was quick to share her thoughts. Her observations were sometimes caustic, sometimes funny, always insightful.

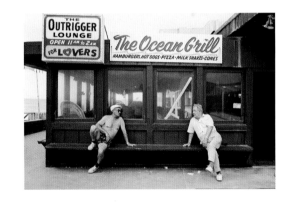

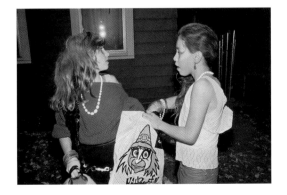

That must have been where I first learned to pay attention to the world around me, to see with a sharpness—the way my mother did—the exchange between two people.

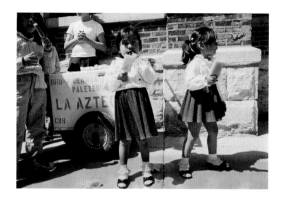

Photography became my way of seeing and commenting on my observations at the same time.

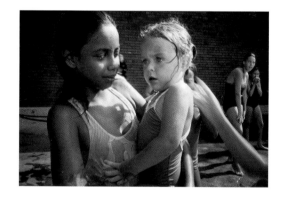

Making pictures begins with the desire to discover, to find what time and light can reveal.

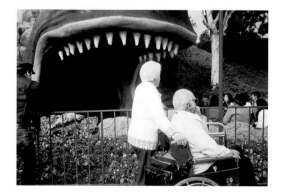

My work is grounded in paying attention to what is in front of me. I've found this to be a richer and more surprising source of imagery than anything I could invent.

No matter how uninspired I feel, how dull I think a place is, when I look at the world through a camera a new beginning takes place.

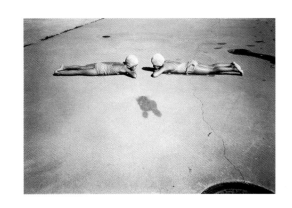

We've all heard stories of people who find their heart's desire the minute they stop looking for it.

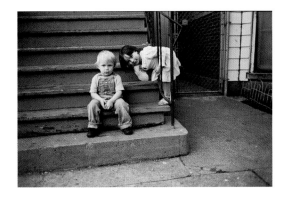

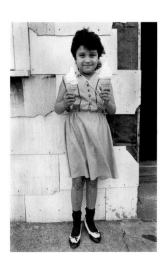

What I found when I wasn't looking were pairs of every manner and kind.

—MELISSA ANN PINNEY, EVANSTON, ILLINOIS, 2015

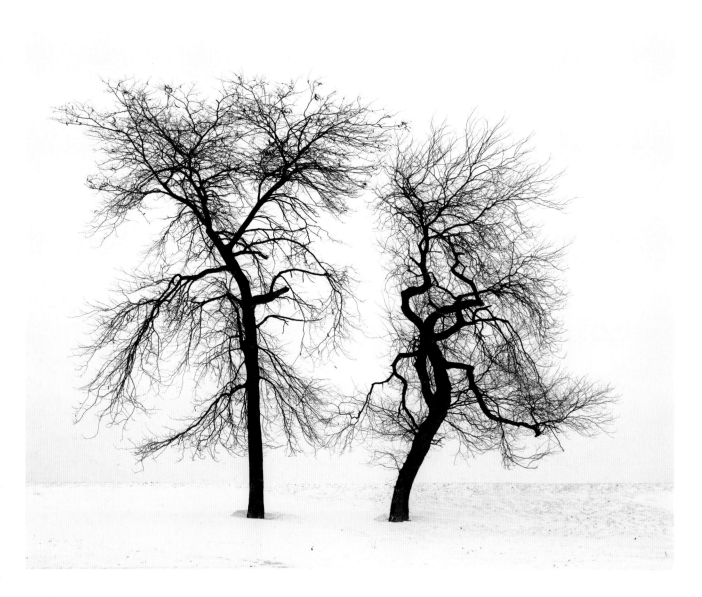

TWO: AN INTRODUCTION

The story of *Two* starts on the third floor of my friend Melissa's house, up the narrow stairs to her studio where photographs are framed on the walls and spread across tables and scattered and stacked on the floor. Giant corkboards cover two of the walls in the main room, and on those boards Melissa has pinned dozens and dozens of prints, each one containing some sort of pair: an elderly couple in a swimming pool, a woman with her dog, two winter trees cutting dark lines against the snow.

"I'm starting to think about a new book," she told me. "Things in pairs. Two things."

I stood and looked at the wall. I've certainly had the experience of reading books that grabbed me from the first sentence, but I didn't know I could be grabbed from the first image. I'd never encountered a book pinned up page by page before and I couldn't take my eyes off of it.

Melissa and I first met over photography a dozen years ago when an envelope of her work arrived in my mailbox along with a letter asking me to write the introduction to her book *Regarding Emma*. I felt an immediate connection to Melissa's work, to the way she managed again and again to see what was extraordinary in the people and moments that others might overlook—that I might overlook. Not long after that we met in person, and from there we became friends, and then close friends. I helped her sort through prints for her second book, *Girl Ascending*, and once again marveled at what she was able to do with water and light and time.

Standing in her studio, looking at the sets of figures and objects on the corkboard, the girl in the red cape alone with her shadow, two Amish men staring at the sea, I was struck with both the comfort and the tension these pictures contained. Doesn't everyone lean towards another? Even as we're alone, don't we seek out some other half to fill in our story?

I have a particular talent for being alone. Most writers do. When people tell me they'd like to have a job like mine, I often think that the proof doesn't lie in the talent or the intelligence you have, or even the story you want to tell, as much as in whether or not you're able to be alone with your thoughts and make something from them. That's the thing that sets the writers apart from the people who want to be writers—the ability to remain still and alone for long, unrewarded stretches of time and to fall into other worlds without anyone else knowing or caring. You can be smart and talented and have the most compelling story, but if you can't make yourself sit down and block out the noise around you, then that story will remain forever in your head. The photographers I've known have a similar drive to be alone, though it's harder for them since they're so often in the presence of other people. Being alone with other people, concentrating while remaining invisible in a way that makes people forget about you completely, is not a job for amateurs.

Somehow, it's my ability to be alone that attracts me to these images of pairs, in the same way that Melissa, alone behind her camera, sees the twosomes in the world around her. Those of us who are best at solitude marvel at the easy comradery of two sisters, two lovers, two cups balanced, one inside the other. Looking at the prints lined up across the corkboard, the book made perfect sense to me. My job would be to make sure this book found its audience.

Why I saw that as my job not only has to do with the nature of friendship and my love for this particular body of work, but also with my changing relationship to books. In November 2011, my business partner Karen Hayes and I opened Parnassus Books in Nashville, Tennessee, and while I had long been a reader and a writer, I was now a bookseller as well. From the first moment I saw Melissa's pictures, I found myself thinking about how to get this book into the hands of the people who would want to find it. I suggested that we combine the images with a series of essays, essays that didn't respond to the specific photographs but spoke to the nature of *two*. My hope was that the words and images would inform one another and expand what we were seeing and reading. Melissa said she was in. I contacted ten writers I know and admire and asked if they would contribute a short essay, or, in the case of Billy Collins, a brilliant poem, on some aspect of two. The work that came back from that barest nudge surpassed all expectations. I received powerful imaginings ranging in every direction—long marriages, devoted chickens, friendships, foot washing. As I've said, making art is so often work done in isolation, and while contributing to this book wasn't about making art together, it was about knowing that your art was going to stand as part of something larger. The photographs and the essays joined to make their own sort of two, not so much a collaboration as a reinforcement.

If I had written an essay for this book rather than an introduction, I would have written about the reader and the book. Book after book after book, this state of two has been one of the longest, deepest, and most enlightening pairings of my life, one that has let me exist both alone and in the world. Books, and this book in particular, have brought me a joy that I would wish for everyone. This is where the story begins.

—ANN PATCHETT, NASHVILLE, TENNESSEE, 2015

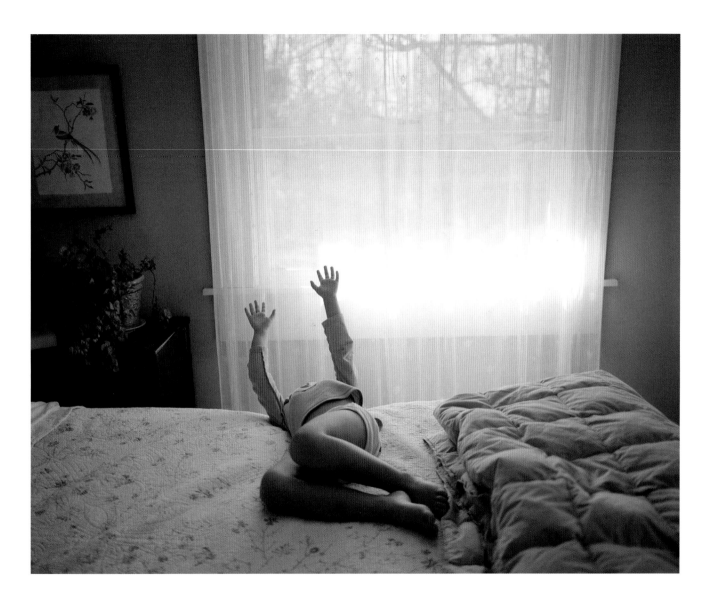

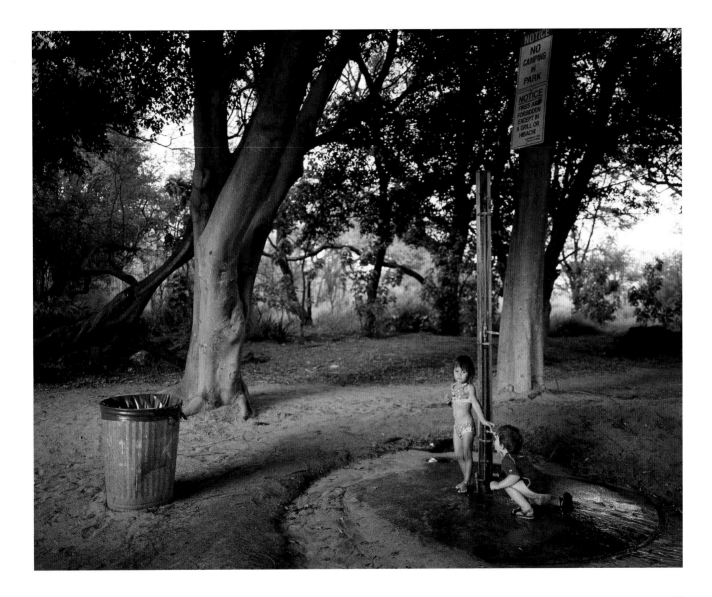

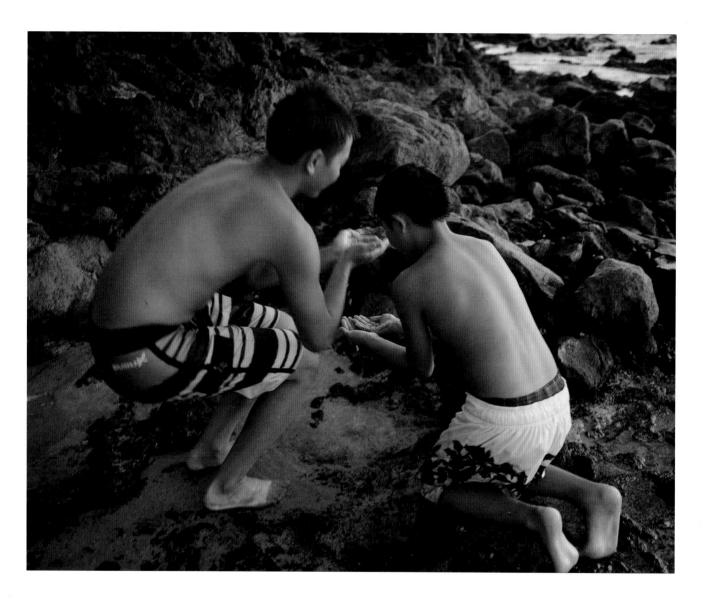

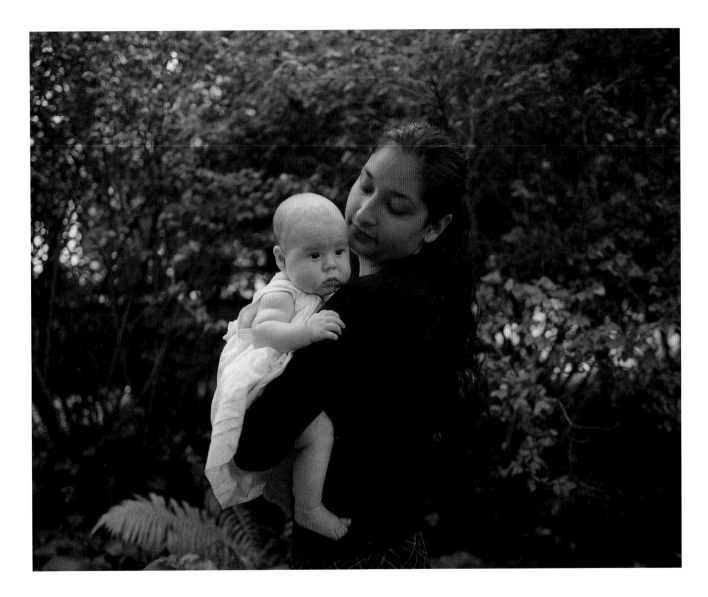

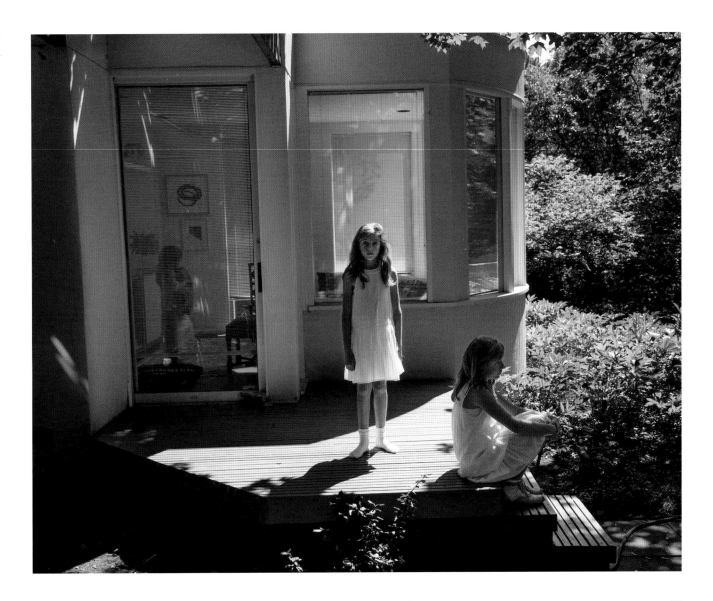

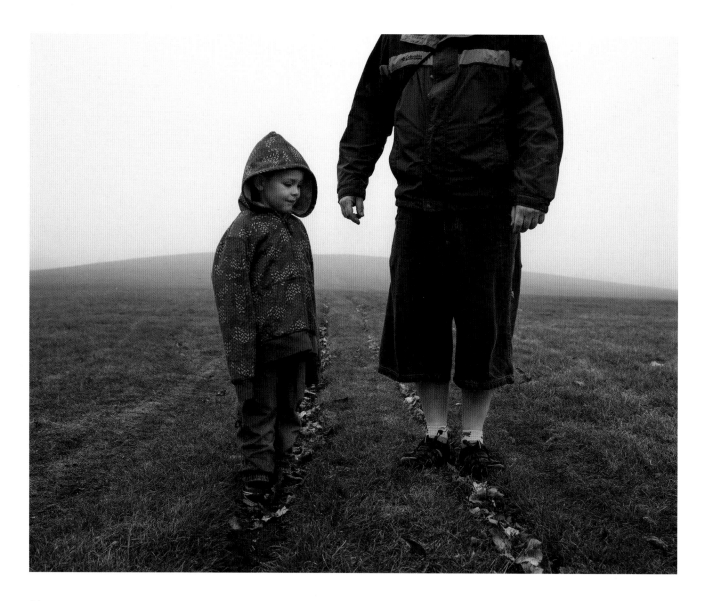

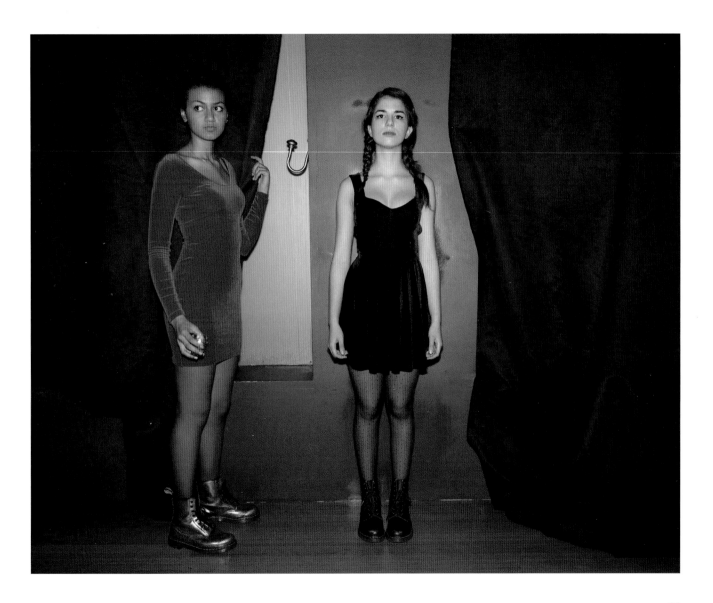

TWO HANDS AND TWO FEET

EDWIDGE DANTICAT

occasionally attend a very small church, where once a month the members take turns washing each other's feet. Though I had been visiting for some time, it took me a while to build up enough courage to participate. First of all, I don't have pretty feet. Unwilling to put anything between the ground and myself—unless it's a really cold day or I'm going out—I mostly go barefoot, which has led to my having chronically cracked heels and thick, unseemly soles. Which is only partly why I approached the foot washing with a mixture of trepidation and horror. The other reason was that I thought it was yucky.

Foot washing, the pastor explained, was very common in many ancient cultures, where it was considered courteous to offer a guest a basin of water to tidy up his or her feet upon arrival. Usually the visitor, who had most likely traveled long and dusty distances in sandals, would wash his or her own feet or would be offered a servant for the task. In cases where the visitor was an especially treasured or important person, the head of the household did the foot washing.

Washing someone's feet in a Christian context has its model in Jesus washing the feet of his disciples at the Last Supper. If he could humble himself before them, Jesus told them, so could they be humble in their treatment of each other.

I kept reminding myself of all this as I entered the plain white room off the main sanctuary where the foot washing was to take place. First of all it was much more intimate than I'd expected. Rather than a group wash, where people line up in rows, or where a leader washes the feet of an entire congregation, there was only one other woman in the room. It was just the two of us.

When I entered the room, my foot washer was already sitting on a low stool near a white ceramic basin and seemed to have been waiting for me. I didn't know that particular sister very well, but I knew her story. A year before she had been pregnant with her third child, and after her blood pressure had risen out of control, she had been placed on bed rest for several weeks. Not being a close friend, I hadn't visited her at her house. Still, when she returned to church with her baby, an especially large and happy boy, she blissfully embraced everyone in the congregation, including me, thanking us for our prayers and moral support.

During the weeks that followed, every now and then whenever I sat near her, I would hold that chubby boy, her miracle baby, while she went to use the rest room. He was so heavy that my arm would go limp before she returned. Beyond that mostly silent exchange, she and I never had a real conversation. And now we were together in a small room, trying to re-create an ancient ritual.

Without speaking, she motioned for me to move closer and sit on the higher stool in front of her. I slipped my shoes off my feet, which I had scrubbed especially hard for the occasion, and I let them sway above the water. Leaning forward, she bowed her head as her hands carefully guided them into the basin. The water was welcoming and warm, and as her fingers cupped handfuls and poured them over my toes, I felt ticklish. Pulling my feet deeper into the basin, she gently massaged my arches. When she was done, she toweled my feet dry and helped me place them back in my roomy, flat shoes.

We switched places and now it was my turn at her feet, which unlike mine were fine, beautiful, well manicured. I could suddenly see her staring at them, propped up for weeks as she lay in bed, hoping, waiting, and dreaming about a future with her son. I gave her feet a real scrubbing, as though she were a dusty-footed visitor who'd just entered my home. Her face did not betray the surprise she must have felt. This was symbolic after all. But I knew no other way to do it. I knew no other way to try.

With her two feet in my hands, I couldn't help but think of a reflexology chart I'd once seen, a diagram that linked every part of our feet to an organ in the body. Here I was, by maneuvering her toes, connected to her brain, and by touching the middle of her feet, to her kidneys, lungs, and heart. The place she held her son, I had under my pinky. Through touch, we were thoroughly linked not just symbolically, but for real.

Going in, I knew that foot washing would be a purposefully humbling public experience, but I had not expected it to feel so intimate, so à deux. I had read about nuns who'd washed the feet of lepers to teach themselves the lessons of true humility. Some of the washers from our

church had even kissed the feet of their brethren after washing them, something I didn't have it in me to do. What I didn't expect though was that foot washing would also make me feel stronger in a way that one only experiences by extending one's self, one's hand, toward another. It was strange but for some reason, at that moment I no longer felt like one person. I felt like two.

After we'd washed each other's feet, the sister and I hugged. We lingered in our embrace, purposefully acknowledging that we now knew each other in a slightly different way than we had before. We touch the people we love all the time. Or at least we should. But to touch another person we don't know as well can sometimes feel bold, even dangerous. That is until our life's paths surprisingly merge, if even for an instant, in water, between two hands and two feet.

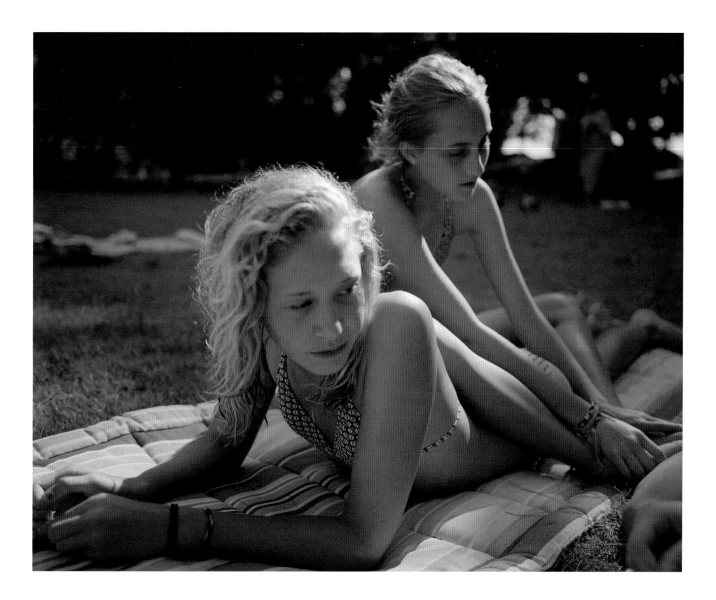

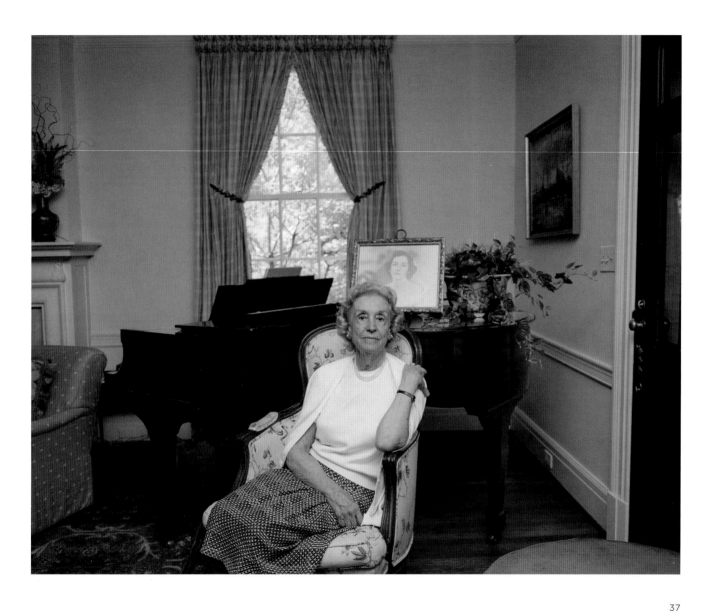

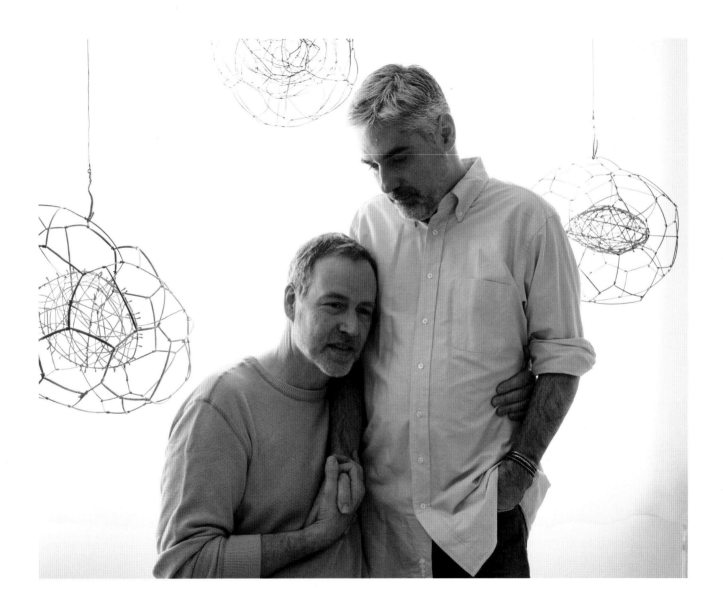

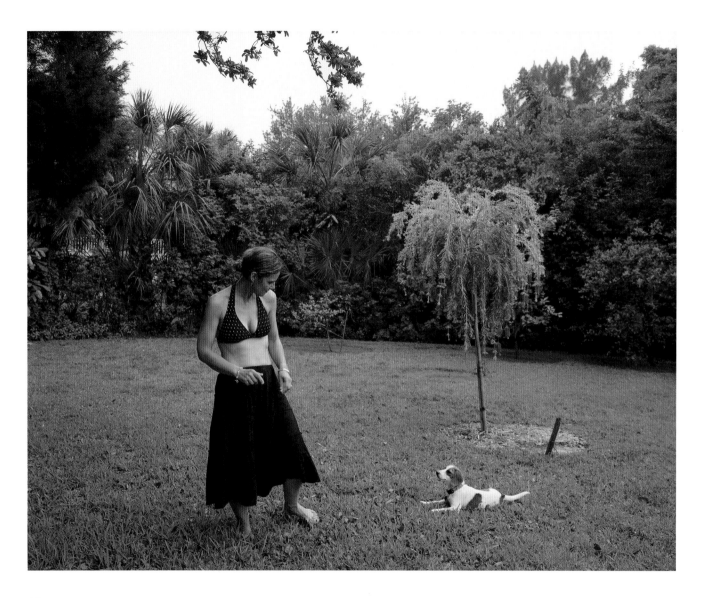

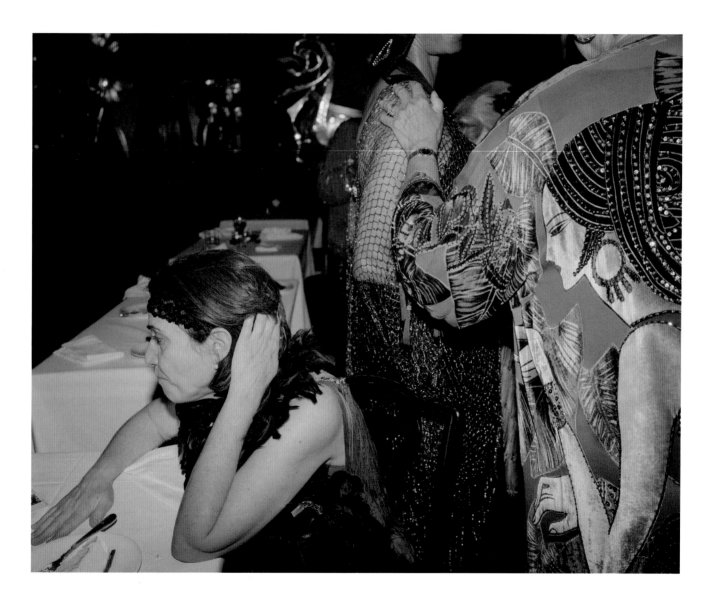

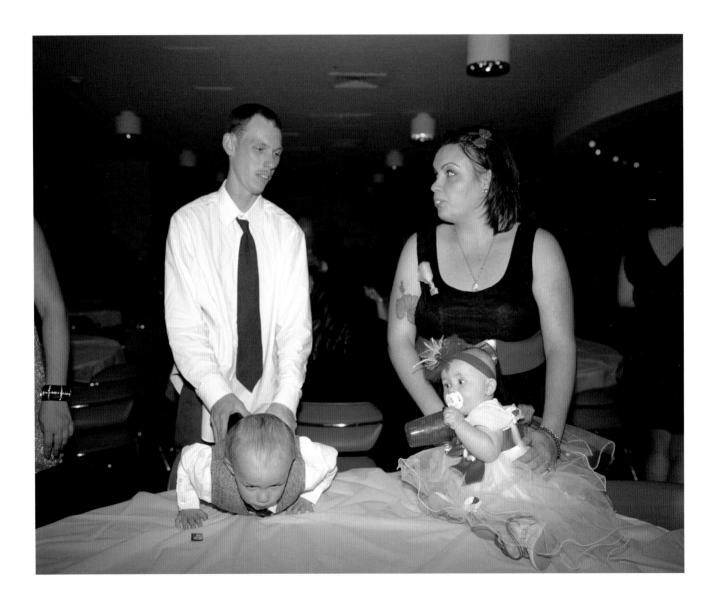

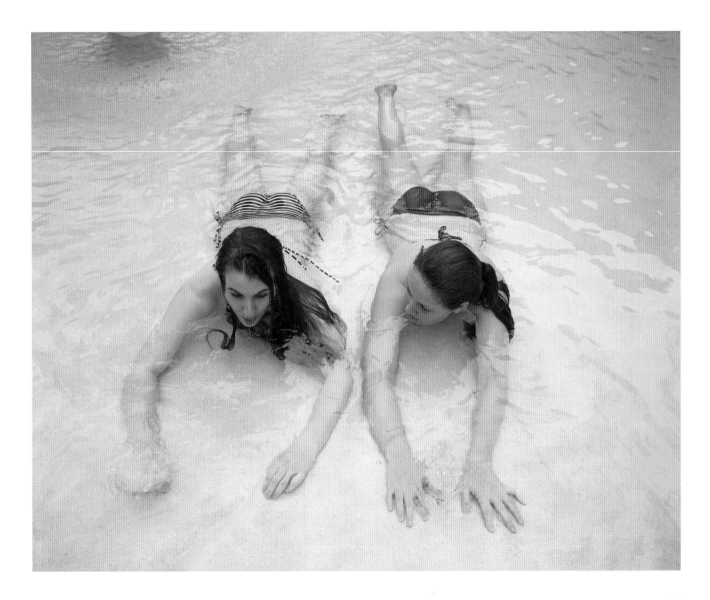

THE PAIR

BARBARA KINGSOLVER

It's the most senseless of all wishes: they never should have had me.

And even so, it's a common enough betrayal among human issue, whether we say it or not: these two should not have been parents, mine or anyone's. Believe me, I'm not wishing myself away. I'm thankful the firmaments gambled as they did on the grand gametic blunder that gave me this minute, these particular decades, these eyes, this thought, this shot at one life and no other. Of the whole bolt of cloth that is time, I've got my scrap after all. I'm only saying these two were not cut out for the arrival of the third party, the fourth, and so on. They were cut out for one another.

The story they always told was a children's tale—love and a school cafeteria. He worked his lunch hours there, nickel-and-diming for college, doling out school potatoes with a dull steel ladle—as I imagine this scene—and she was simply *she*. The slender, dark-lit beauty, the only face he ever saw in the crowded room. He taped a valentine to the underside of her tray.

And for all of time they became fixed, just there: he with the earnest valentine, *she*, the only one in any room. In the wedding photo they stare into each other's eyes, mesmerized, as if gazing into a crystal globe that could hold no possible fortune but their happiness. At that moment they are scarcely grown, all elbows and satin sheen, flanked by the ruffled neck-tied bafflement of the castaway maids and parents. The velvet-upholstered parlor holds no more oxygen: the lovers' flame is that greedy.

Nothing will ever touch these two again. No more dull potatoes, no dark skies, no cry in the night, nothing. Down through years and years will come the photographs, she before the camera and he behind it, the one beheld and the other transfixed; the camera is his valentine. In the center of every frame she sits surveying the unblemished reign of her fortune, her skirt swirled round like a flower, her perfect smile a vortex. One after another the backgrounds recede behind her, variable and irrelevant: a landscape, a tower, a graduation, a foreign land, a dinner table, a house, a child. Oh yes, the children appear in time but only as ghostly slips, too pale to mount any serious incursion, never fully formed or in focus, not even for birth announcements or birthday parties. Thousands of photos locked in treasure boxes gather dust now, the golden anniversary gazes have all been gazed, and to this day there cannot be found one portrait of a child that came of this union.

And yet, so many portraits of that childhood. Look. Here is a small chubby arm at the edge of the frame, held in place while *she* in the center leans forward fetchingly in lipstick and earrings to blow out the cake's one candle. The arm is mine. The flickering candle is proof of my native atmosphere, a vanishing oxygen that still flattens my lungs in memoriam. Each

photo bears the same caption: *We're So Lucky!* Through every dark dream and hunger pang in the house of the unassailable love, *so lucky*, and who would I be to say they were not.

I have searched these photographs for signs of myself, and am gratified to find the truth: my wild attachment to solitude and the howling wolves, the brethren orphans, the comforts of invisibility. Now I crowd my own children close, by the armful, filling frames with them, slaking a lifelong craving to recede into a landscape. I know my place. I cleave to it.

How many times in childhood did I scan a horizon and see to the end of our family? We are all in a boat, capsizing. I glimpse the pair as their gleaming, competent limbs rise above the water, grappling for rescue, swimming in tandem for shore, and once they have safely reached it, embracing as their eyes lock: *Oh my beloved, we are saved!* And only later they muse: *But wait, were there children?*

Oh idyllic exalted state, the charmed Romeo-Julietness of it all: the pair. Forsaking all others. Before we are trained to crave it, children know to be wary. If we should open a door and happen upon these two, we know to be still, breathe carefully. Step quietly out of the room.

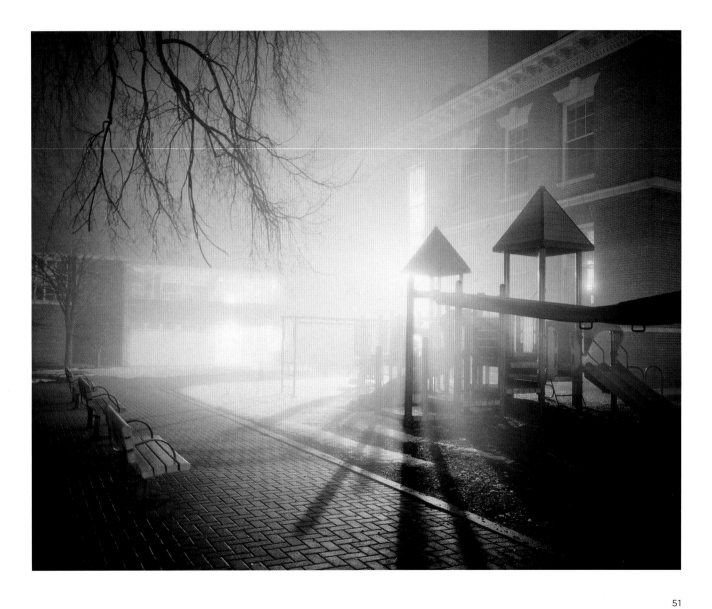

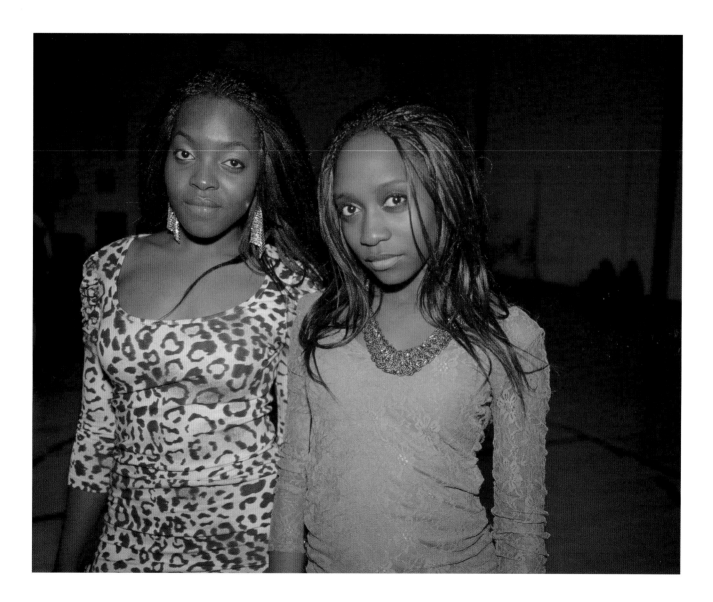

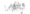

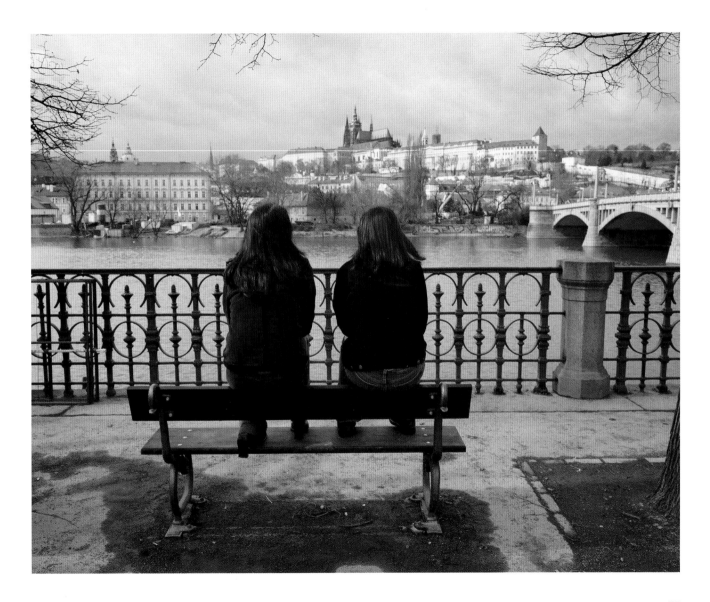

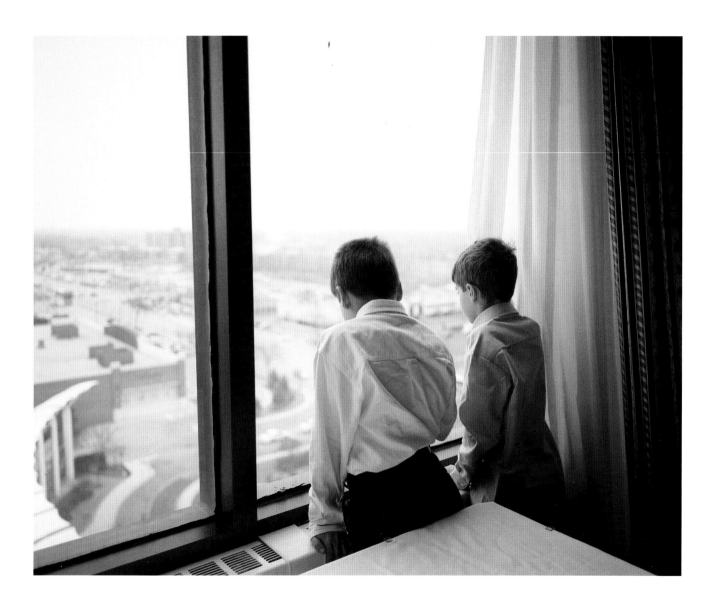

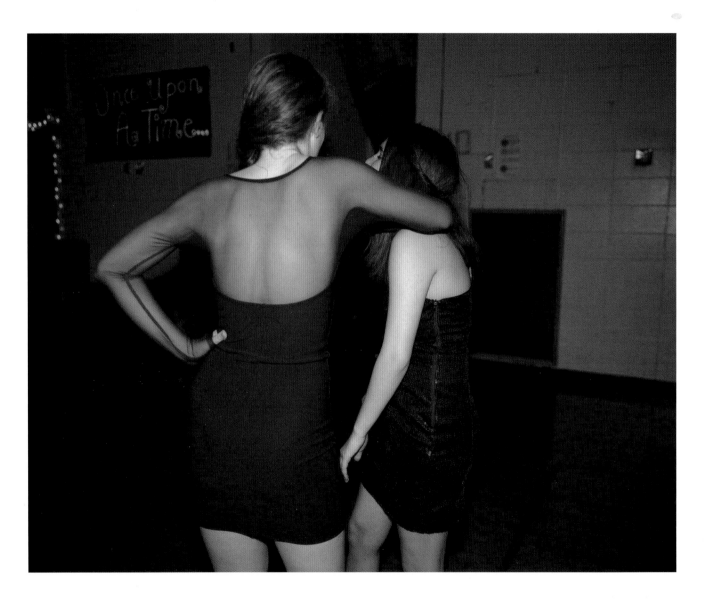

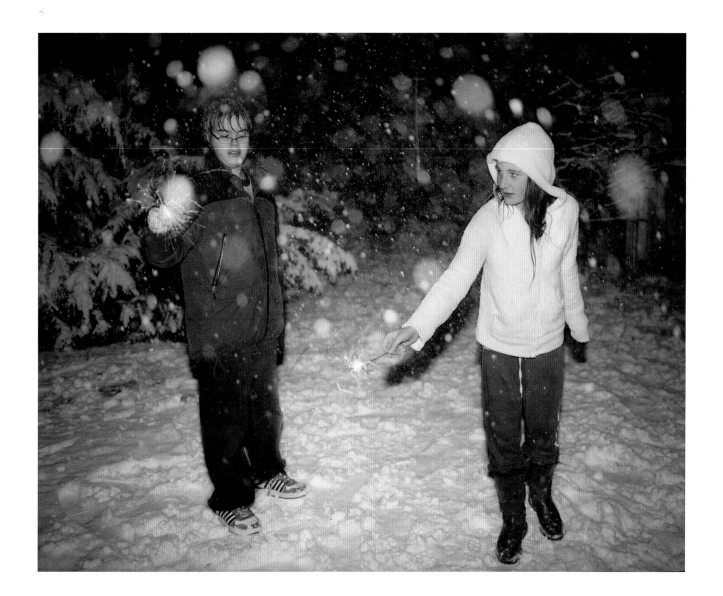

TWO CREATURES

BILLY COLLINS

The last time I looked, the dog was lying
on the freshly cut grass
but now she has moved under the picnic table.

I wonder what causes her to shift
from one place to another,
to get up for no apparent reason from her spot

by the stove, scratch one ear,
then relocate, slumping down
on the other side of the room by the big window,

or I will see her hop onto the couch to nap
then later find her down
on the Turkish carpet, her nose in the fringe.

The moon rolls across the night sky
and stops to peer down at the earth,
and the dog rolls through these rooms

and onto the lawn, pausing here and there
to sleep or to stare up at me, head in her paws,
to consider the scentless pen in my hand

or the open book on my lap.
And because her eyes always follow me
she must wonder, too, why I

shift from place to place,
from the couch to the sink
or the pencil sharpener on the wall—

two creatures bound by wonderment
though unlike her, I have never worried
after letting her out the back door

that she would drive off in the car
and leave me to die
behind the many locked doors of this house.

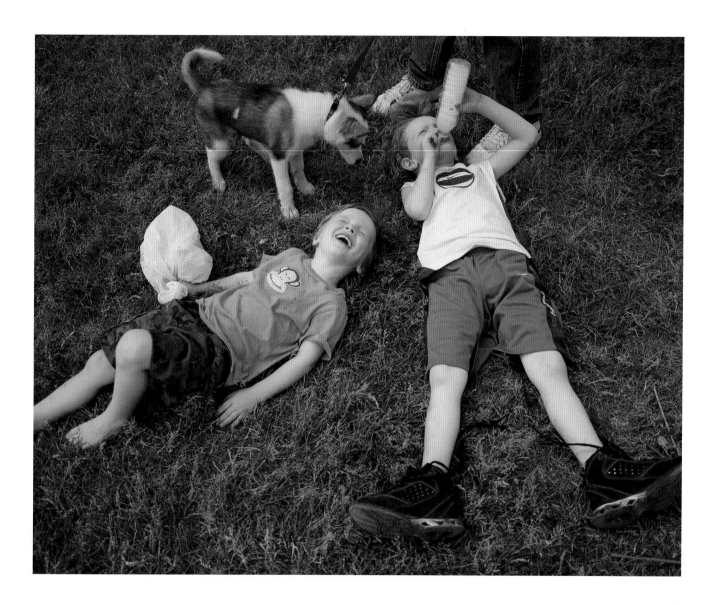

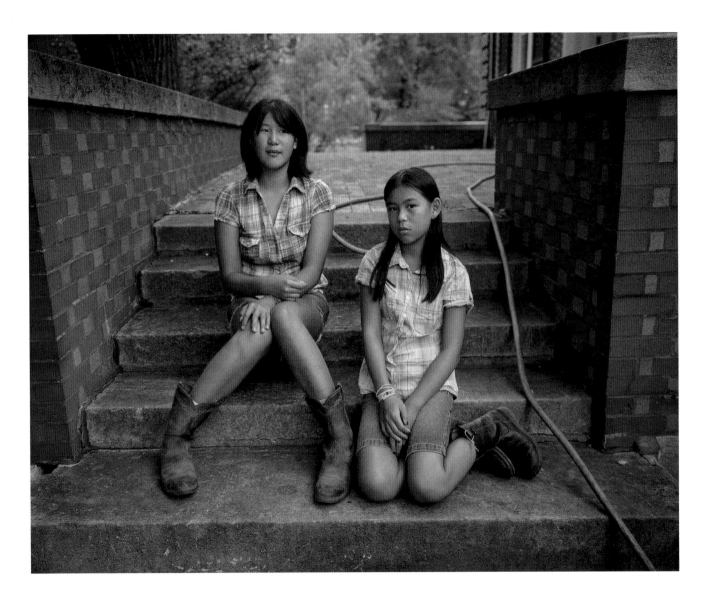

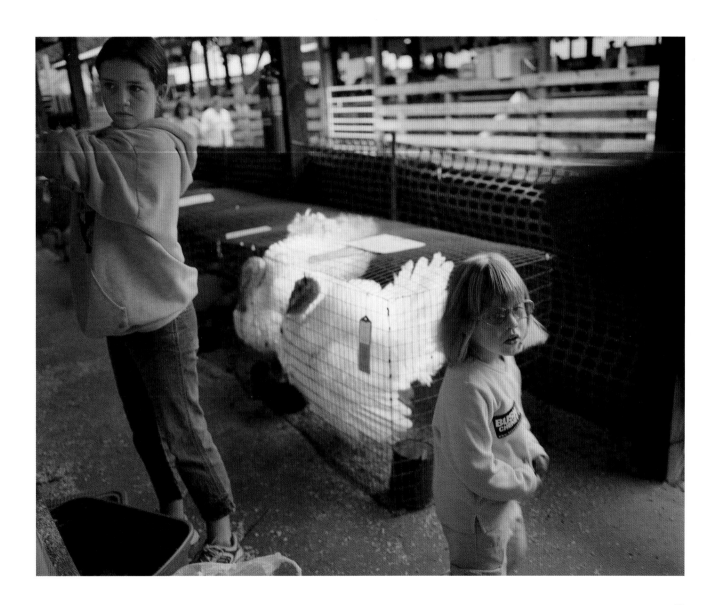

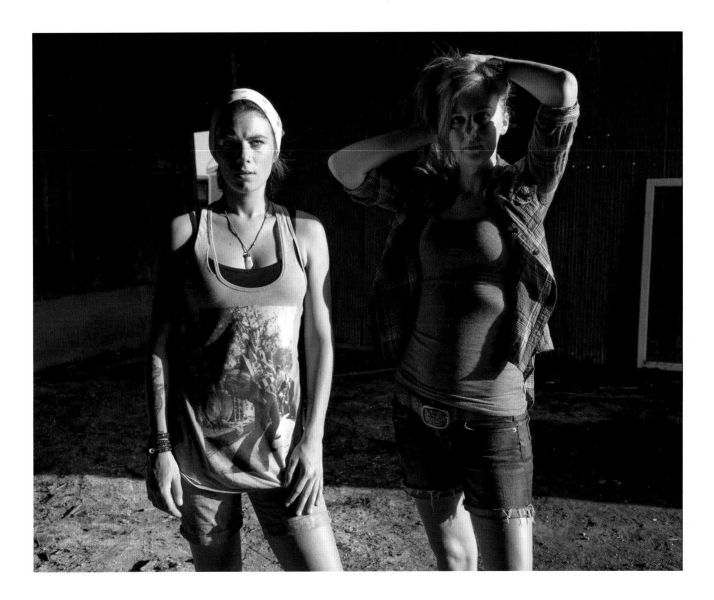

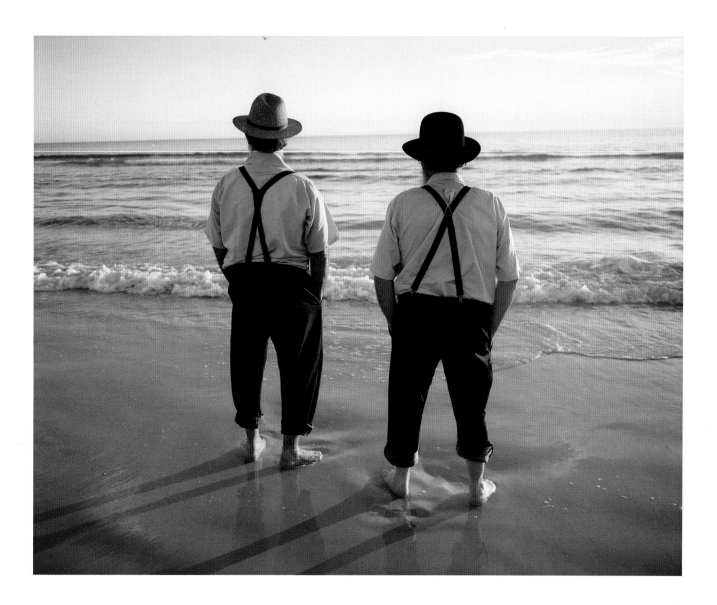

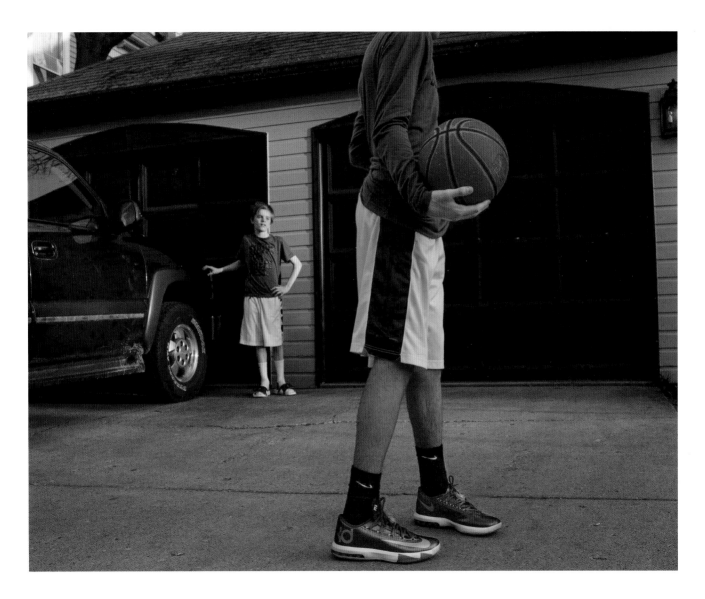

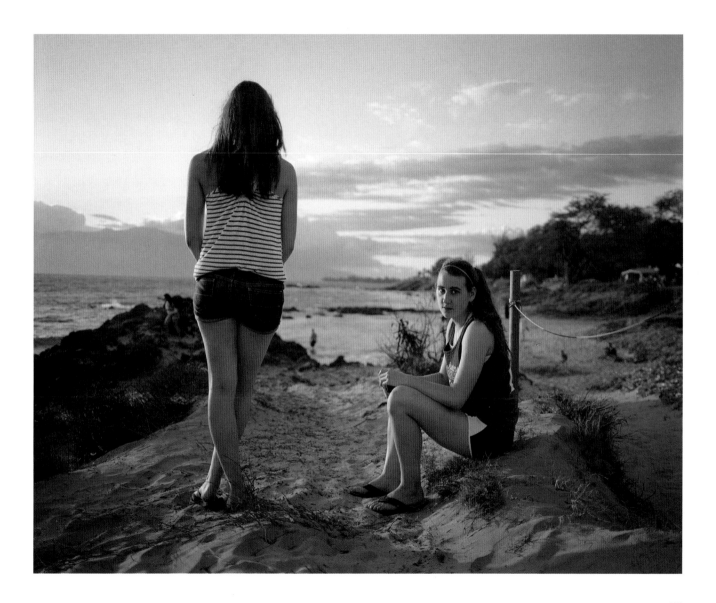

STRATEGY

RICHARD RUSSO

I'm twelve years old and it's the first day of middle school, where over the course of the next two years I will discover that I'm average, though as yet I have no inkling of this. The elementary school I attended was the smallest in the city, and in that small pond I'd been a relatively big fish. But in truth I'm small for my age and not very strong. My father, whom I almost never see, is just under six feet tall, though, so I'm confident of a growth spurt. Meanwhile, I content myself with speed. I can outrun any boy in my neighborhood, and I believe that despite my short legs I will get faster still. I read above my grade level, and my mother tells me I'm very smart. I believe her. I also believe I'm good looking and will, in time, become a ladies' man. I've decided I want to be like Billy Cannon, the handsome LSU running back who's described as a triple threat. He can run the football and also pass it and he poses one other threat I'm unclear about, but I like the sound of "triple threat" and am certain I can become one.

After lunch in the school cafeteria, us seventh grade boys, a rowdy bunch, are herded into the gym. There, pushing and shoving, we climb the bleachers, where we are told about gym class.

I'm beyond excited, looking around at all the other boys I intend to outperform over the next two years. They're excited too, but mostly because our gym teacher is also the high school football coach and a legend. He's a very large man, no doubt handsome once, but gone to seed. He wears sweat clothes and sneakers, and when he blows the whistle he wears around his neck, the gym falls silent. "Listen up, fellas," he says, and we do, because being addressed as "fellas" makes us feel grown up. When our attention flags, all he has to say is "Quiet down, fellas," and you can hear a pin drop. He is the only teacher in the school who doesn't have to raise his voice. Today, we're with him for only fifteen minutes, so he uses the time to tell us what we'll need to purchase at the town's only sporting goods store: a gym bag, athletic shorts, a couple of t-shirts, good cotton socks. When there's less than a minute left, he says, "One more thing, fellas," and something about his tone, the fact that he's lowered his voice even more and appears embarrassed, makes me wary of what comes next. "You'll need to wear a jock strap, fellas."

Fast-forward twenty-some years. I'm now in my mid-thirties. I've published my first novel, and I'm working hard on my second. I'm a visiting writer in a low-residency MFA program in North Carolina. Many of the other writers have a good half-dozen books to their credit and the students in the program are very talented, so all in all I'm less confident than the seventh-grade boy who sat on those bleachers so long ago. There have been disappointments. I've been denied the growth spurt I was counting on and felt genetically entitled to. Nor did I ever become as fleet of foot as I imagined I would, which means I've ended up three whole threats short of a triple. I'm happily married and have two daughters, but I'm not as good-looking as my father by a long shot, and I'm the farthest thing from a ladies' man. My average intelligence has been sufficient for me to become a pretty good writer, which is less about smarts than most people

imagine, but I have to work hard at it. I'm just smart enough to know how blessed I am, and for that I'm grateful. I am, I like to think, an adult.

The faculty and staff of the writing program have gathered in the large lounge to discuss the upcoming residency. There's lots to do: go over the schedule, distribute cafeteria meal tickets and office keys, pair up students with mentors, discuss workshop protocol. We methodically work our way through each item on the agenda. When we finish and begin to gather our things, the program director says, "Oh, there's one more thing," and something about his posture, the way he's lowered his voice, together with the high color in his cheeks, makes me strangely anxious. I half expect him to say, "You'll need to wear a jock strap, fellas." And for a moment I'm back in that gym, a seventh grader, his trumped-up self-assurance just that moment detonated by ignorance—by not knowing for sure what a jock strap is, by not having a father around to ask, by having no idea how to ask for one at the sporting goods store, by not understanding that they're sold by waist size, by wondering if I'll have to be fitted and by whom.

What the program director actually wants to convey, especially to us new faculty, is that in *this* writing program, unlike some others, we don't sleep with our students. He would rather not mention it at all. He doesn't mean to suggest that we *would* sleep with our students. Still, just so there's no confusion....

How odd and yet how universal is the strategy to save for last what we'd prefer not to address at all, to leave it off the printed agenda, to thereby pretend *(oh, yeah, I almost forgot)* its insignificance. Are we ever more alone, more lost, than in the moment we sense what's coming, the uneasy instant before it comes scarily, hilariously into view?

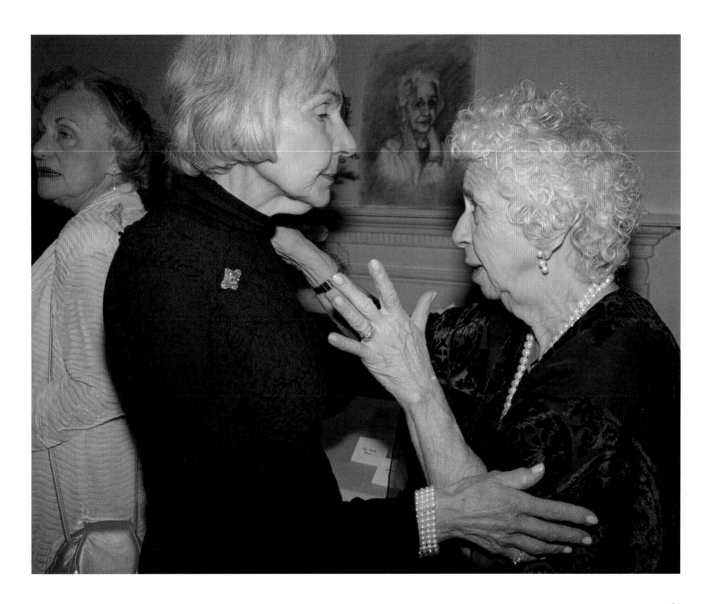

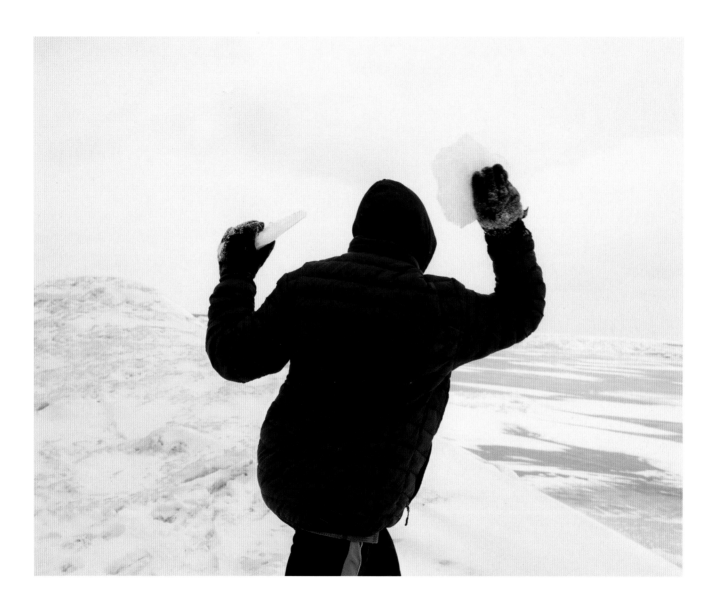

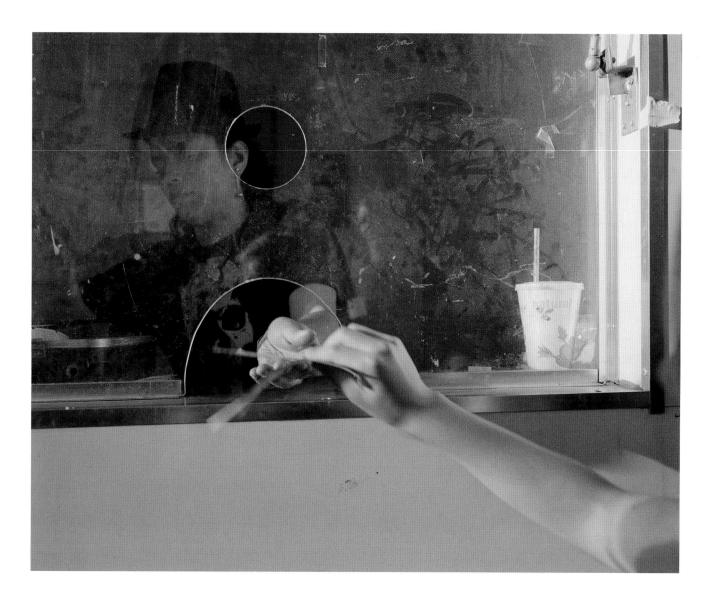

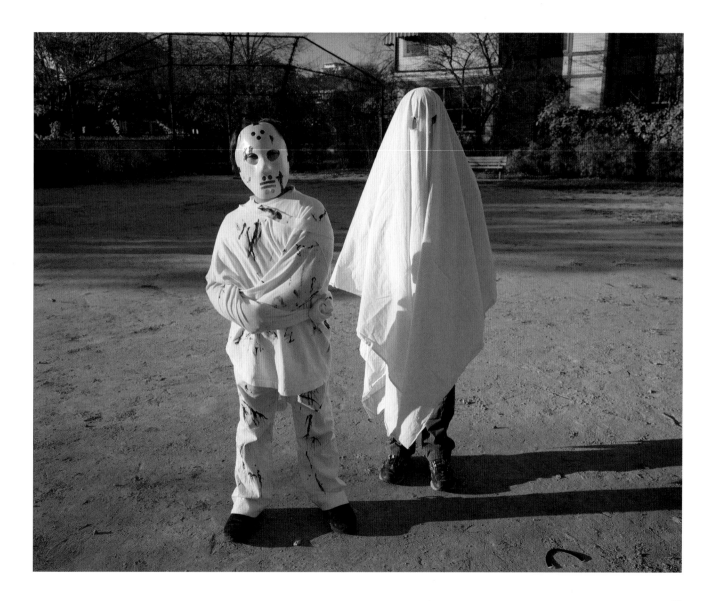

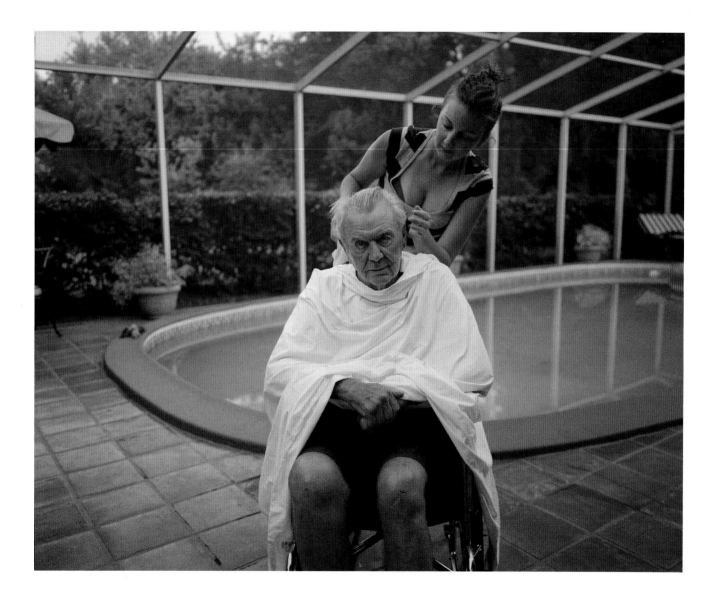

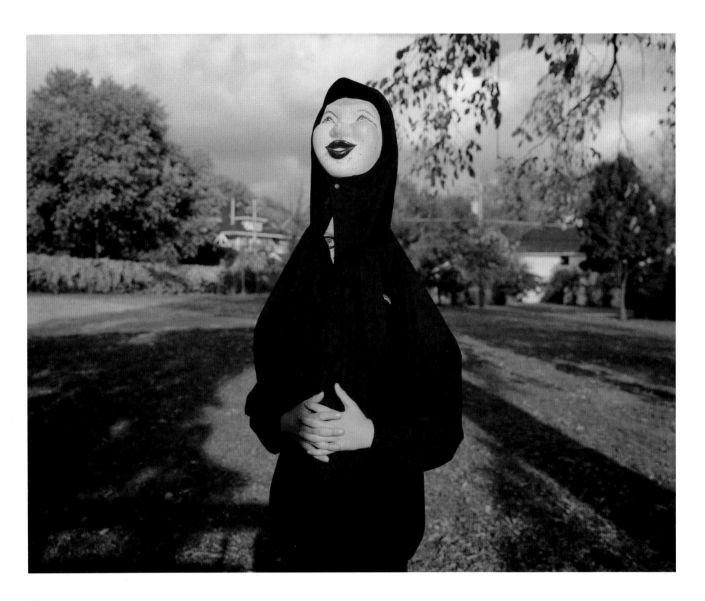

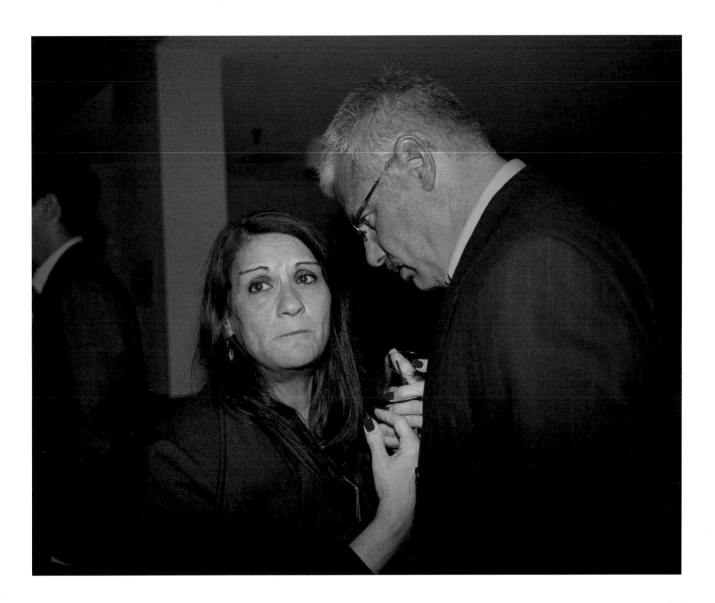

TWO HEADS ON A PIKE

ELIZABETH GILBERT

In late 2005, I was working on the final edits for *Eat, Pray, Love*. The manuscript had already been through several rounds of in-house copyediting, but was still stubbornly riddled with typos and errata. Some of these were decidedly my own fault—I write fast and sloppily—but others were just random bloopers (including, oddly, numbers that kept appearing within words, almost demonically, for reasons nobody at my publishing house could explain). Even my Brazilian sweetheart was finding mistakes, and English is his fourth language. I begged my editors to run the book through yet another round of corrections, only to be informed that the galley was just fine as it was. But it wasn't.

Desperate to catch all these lingering errors before the book went to press, I tried to think of somebody with a fresh and precise eye who might be able to clean up my book once and for all. My thoughts turned to a friend I'd made a few years before at an artists' colony—a woman named Anne Connell, who was neither an editor nor a writer. Anne was, in fact, a beautiful painter, whose painstakingly detailed work suggested a mind of exceptional patience and

precision. She was also—if our evenings of after-dinner word games were any indication—a genius with language. I remembered her as someone who selected her every word carefully before she spoke, as though using the sharp, silvery tips of some finely tuned verbal cocktail fork. And she had been on *Jeopardy!* She was really smart.

So I sent a copy of the galley to Anne, with a plea that she take a look at it. She was humble and self-deprecating ("I'm an artist, not an editor!") but agreed out of concern to examine the pages. The next week, she sent me an email whose tone, message, and grammatical scrupulousness completely exemplified what I would eventually come to think of as The Anne Connell Editorial Experience: "Dear Liz," she wrote. "Whoever copyedited this manuscript should fall on his/her/their sword(s) in utter disgrace." She found more than a hundred errors. I was relieved and dazzled and vindicated. And I would never again publish a book without her.

Now we have done three books together, Anne and I. This is how it goes: I send my manuscript to Anne when I think it's basically ready for the world to see, but I don't send it to my publisher until Anne thinks it's *completely* ready for the world to see. What happens in the interim is an amazing months-long process in which Anne lets loose her mad genius in the margins of my manuscript. Without changing my voice at all, she changes everything. She marks my misspellings and mispunctuations, of course—but also catches plot inconsistencies, factual inaccuracies, geographic (and even architectural) implausibilities, dates that don't quite line up between chapters, my overly enthusiastic tics and exaggerations (must I use the word *very* so very much?), and surprising anachronistic usage. (Among the modern words Anne jettisoned from my recent historical novel included "jettison" itself as well as—appropriately enough—"nit-picking.")

While never veering into the realm of disrespect, Anne does not treat either me or my text like a precious object. She teases me and challenges me. She calls me out when I use words incorrectly (what she refers to as "Inigo Montoya Alerts," as in: "I do not think that means what you think it means."). I find myself laughing aloud as I read her edits. I laugh at my own exposed foolishness (how did I manage to write about "the *tenants* of Judaism" instead of "the *tenets* of Judaism," for heaven's sake?), but I also laugh at the twisted beauty of Anne's extreme didacticism. In my latest novel, for instance, I have a character who sails the world with Captain Cook, and who, in Hawaii, witnesses Cook's men "kill two natives and put their heads on a pike." In the margin next to this sentence, in her immaculate handwriting, Anne noted: "2 heads = 2 pikes." Later, over the phone, she further clarified her correction: "It's not a shish kebob, Liz."

And then there was the moment when I wrote that my protagonist reached for her lover's penis, "which had been—like the penises of every Tahitian boy—circumcised during youth with the tooth of a shark."

"Not unless Tahitian boys have multiple penises," Anne informed me, delicately changing the phrase to read: "like the penis of every Tahitian boy."

Who would ever see such things? Who would *care*? Multiple penises, too many heads on not enough pikes—Anne sees it all. Anne cares. Which means I get to fix it up: one spike for each head; one penis for each boy. Thus the universe is set right. And then nobody has to see those mistakes, ever again.

I once heard the novelist Robert Stone complain that he possessed the two worst possible characteristics for a writer—laziness and perfectionism. The great good fortune of my own

writerly nature is that I am neither lazy nor a perfectionist; I am, in fact, a hardworking half-ass. I get my work done fast and without a lot of drama because I was raised by an incredibly efficient mother who taught me from a young age that "Done is better than good." (As she always said, "I get the dishes washed faster than anyone in this house—just don't look at them too closely when I'm done.") Like my mother, I take shortcuts. I let things slide. I push ahead toward completion. The only problem with this approach is that my work—while finished, and always ahead of deadline—is often flawed in the details. With speed comes missteps. I am the enthusiastic researcher, the breakneck storyteller, the extremely confident narrator, the fastest writer in the joint—but I will never be the person with the magnifying glass, inspecting every sentence for dust mites of fallacy or infelicity.

I don't need to be that person, though, because—thanks be to heaven—I have found that person.

I can fly blind because Anne is my eyes.

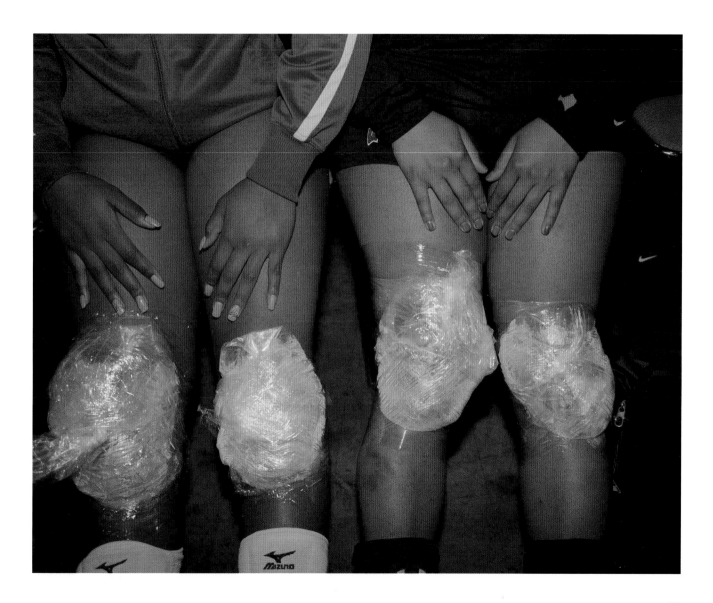

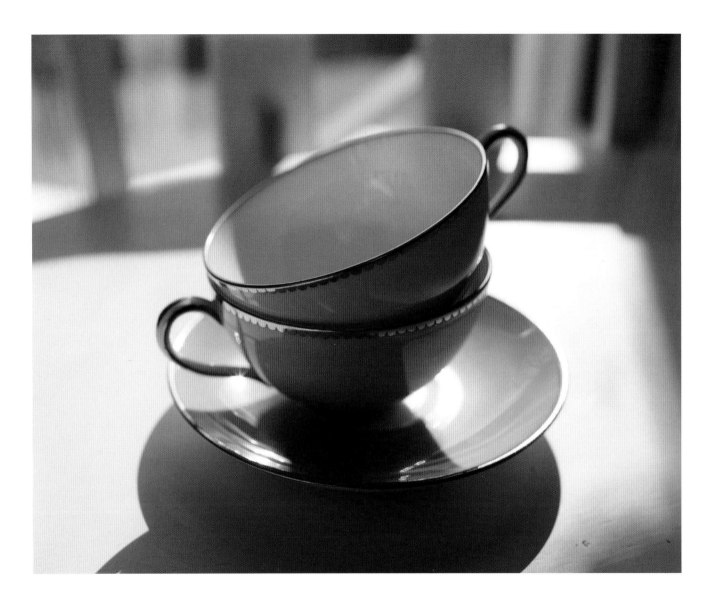

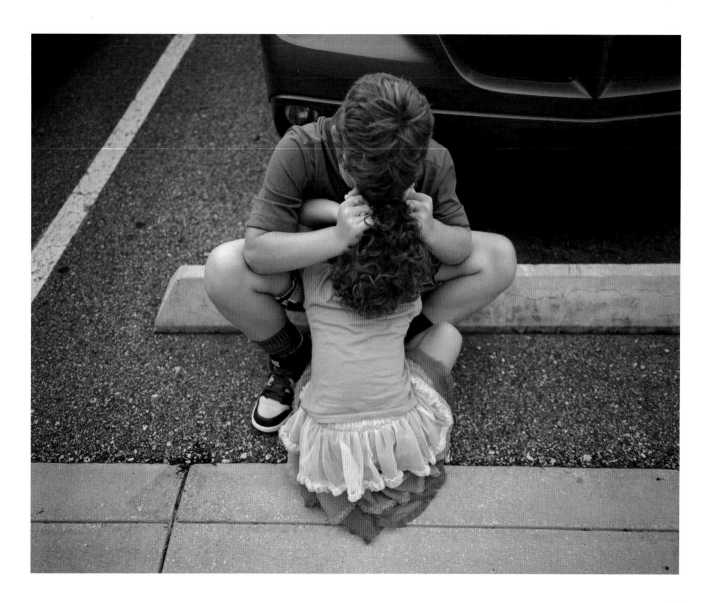

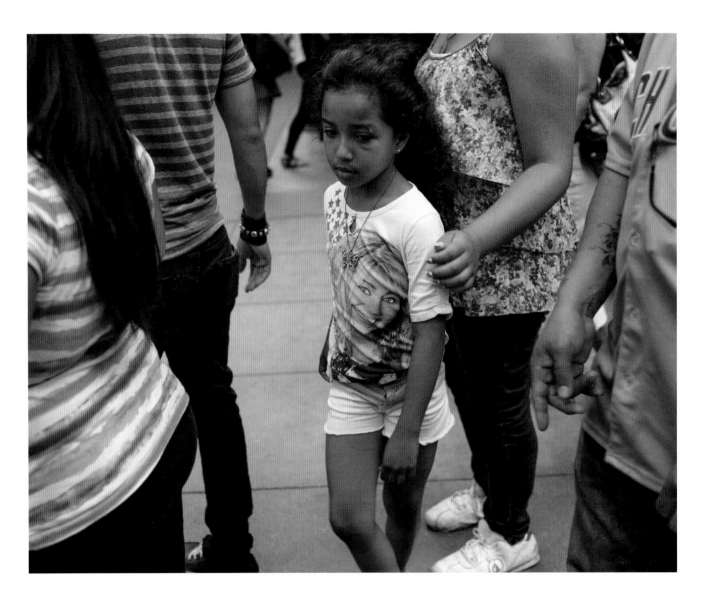

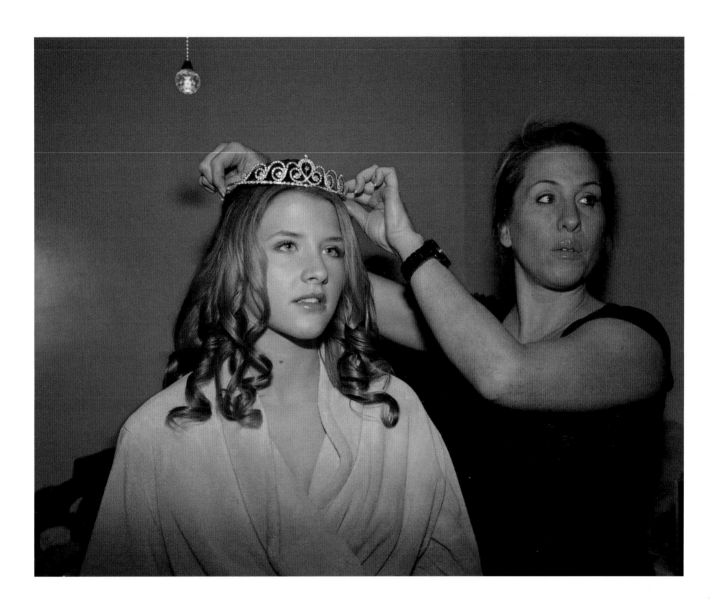

103

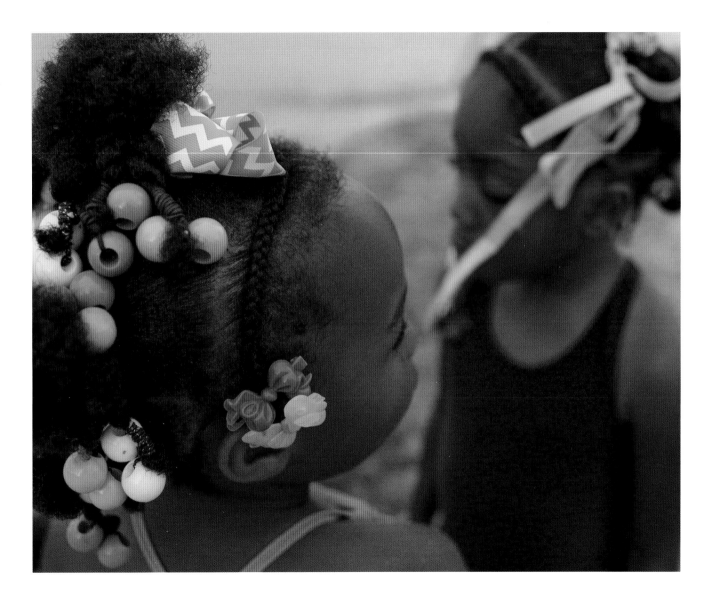

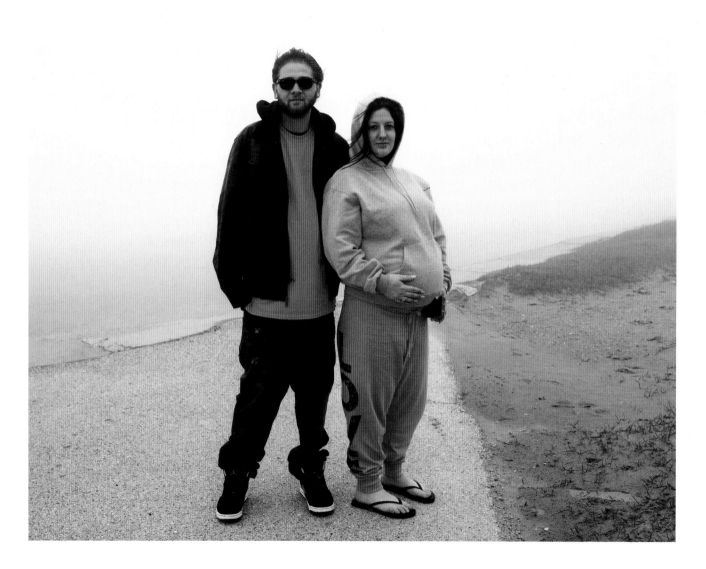

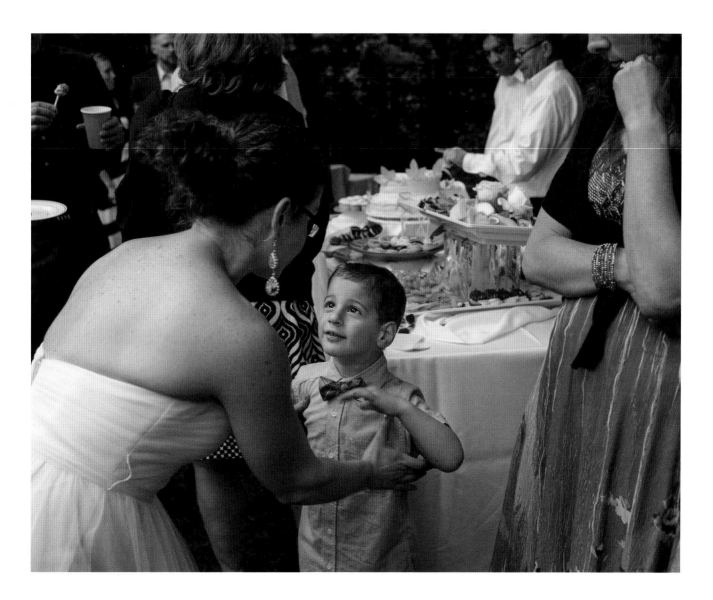

BEAUTY AND TOOKIE

SUSAN ORLEAN

They were quite a pair, Beauty and Tookie. They were inseparable; indivisible, really, never more than a few inches apart, never out of one another's sight. In behavior and size and color and affect they were so well matched that sometimes they appeared to be one hen and a mirror rather than two distinct living beings. Often I wondered if they were sisters. Do chickens have sisters? So many chickens are probably at least half-sisters (one rooster being Father to Millions, I'm sure) that consanguinity might not count for much, or at least it couldn't have been the only reason for their profound connection.

At the time, I had just moved to the countryside and had been stricken, as are many newcomers to country living, with the desire to have livestock. I didn't want anything that might bite me or eat my car, so goats were out of the question. Cows seemed too demanding. Chickens, though, were the right size and level of maintenance for a novice farmer. I ordered them online, as any modern farmer would, and, thinking it might be wise to just dip a toe into chicken husbandry

rather than taking a deep dive, I wanted to start with just one. But chickens don't come in ones. If you order them online to be delivered via the U.S. mail, they come in twos or sixes or twenty-fives, because a lone chicken in a postage box is not a happy chicken: it's a cold chicken and, given the realities of long-distance transit, a very jostled chicken. Multiples keep each other warm, and serve as a kind of living bubble-wrap, cushioning each other against the wear and tear of travel.

So I ordered four. I felt like a real farmer. When they arrived, I immediately wanted fifty. Never having been much of a bird person, I was surprised to find I was very much a chicken person. I couldn't believe how interesting and funny they were, with their mechanical-looking movements and serious expressions and chattering sociability. They marched around, all business, scratching the dirt, perusing the sky, muttering to themselves as they searched each vector of the yard for tidbits. They seemed to find me interesting, too, and whenever I came out to my garden, they made their way over to watch me—they didn't come as close as a dog might, but close enough that it was clear they wanted to keep me company.

I got four—Beauty and Tookie and two more Rhode Island Reds whose names I have now forgotten. You can probably guess this isn't a happy story. I took care of my girls, and locked them in their little coop at night. I pictured danger in the form of hawks, weasels, foxes, raccoons. I didn't consider my neighbors' fat old mutts a threat, because they were so lazy they could barely be roused to bark at the mailman. I lived up a steep hill, and as far as I knew these dogs had never bothered to cross the street, let alone tromp up my hill. I will spare you the full story, because I don't like thinking about it—suffice it to say that very soon after I got my four chickens, I had only two left.

Nevertheless, it was a happy farmyard for quite some time. I added chickens. I added turkeys. One day, on a drive to the drugstore to get some shampoo, I drove past a "Guinea Fowls for Sale" sign that called to me, and I came home with L'Oréal and guineas. I took in some ducks from a neighbor who felt he was "overducked." I woke up one morning to find I had Sebastopol geese—beautiful, vociferous, angry creatures—dropped off by a friend who thought I'd like them. My sweethearts were still Beauty and Tookie, maybe because they had been my firsts, and maybe because they delighted me by their harmony. Chickens can be bitchy and sometimes vicious to each other. They sometimes will murder a new addition to the flock, and if they detect that a bird in their midst is sick or injured, they will dispatch with it. Everyone thinks they're stupid, but they seemed shrewd to me. They keep their world well ordered, whatever it takes.

I noticed one day that Beauty was losing weight. She and Tookie always slept together and came out of the coop together side by side for their morning constitutional, but that morning Beauty stayed behind in the nest. It was strange. I scooped her up and brought her outside, placing her next to Tookie, but her legs crumpled under her and she sat in a heap on the grass. The next day, I took her to my vet, who sent me home with antibiotics, but warned me that he really didn't know what was wrong with her. I dutifully tucked the pills into her beak and drizzled water in with an eyedropper, but she still didn't move, and when I picked her up, her body felt like a puff of air in a tiny cage of bones.

I wouldn't have blamed Tookie if she'd done what chickens naturally do—or at the very least if she had abandoned Beauty as she sat, day after day, on her little mat of hay, her eyes getting milky and her comb growing pale. But until Beauty died, Tookie came in every night and took

her place next to her, as if nothing had changed and the two of them were still a pair, patrolling the yard; cocking their heads in perfect synchronicity when the spiky shadow of a circling hawk passed over them; muttering their secrets to each other—my lovely girls, twinned, entwined, as they settled into their nest, warming each other as the night air cooled and darkness closed in.

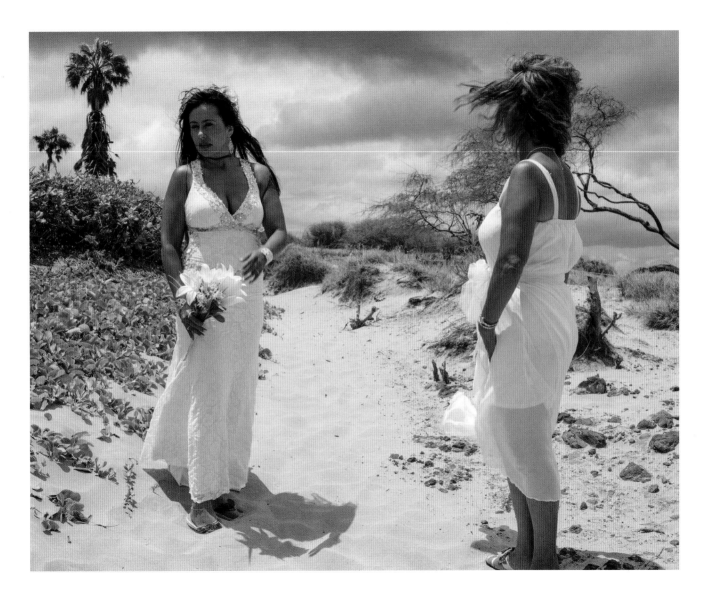

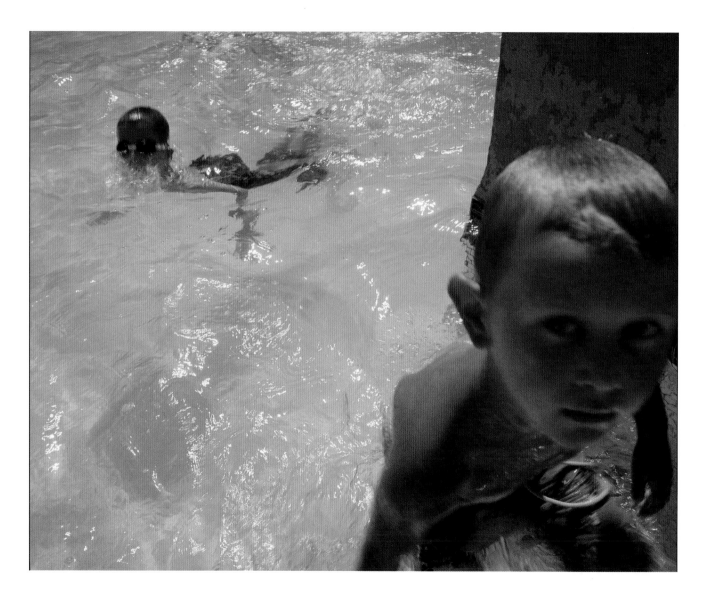

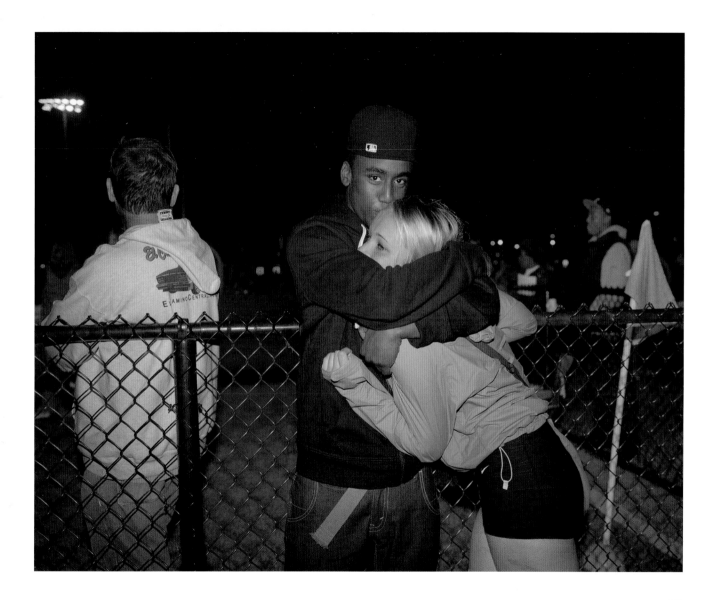

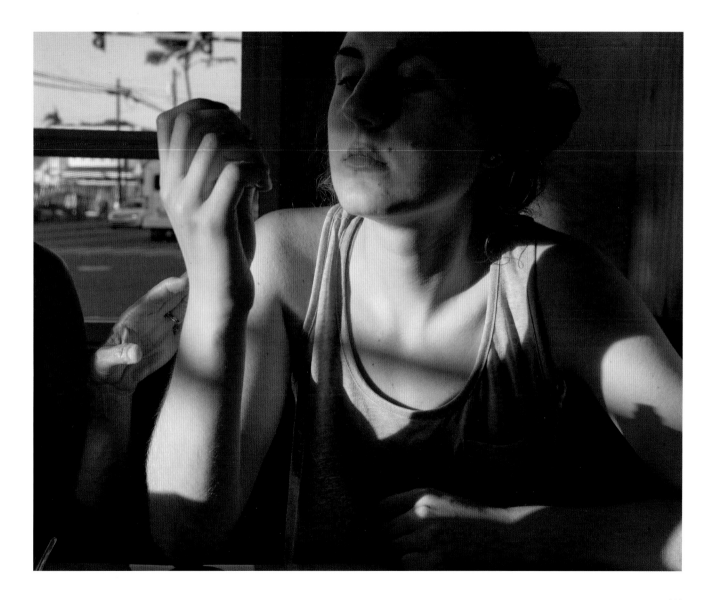

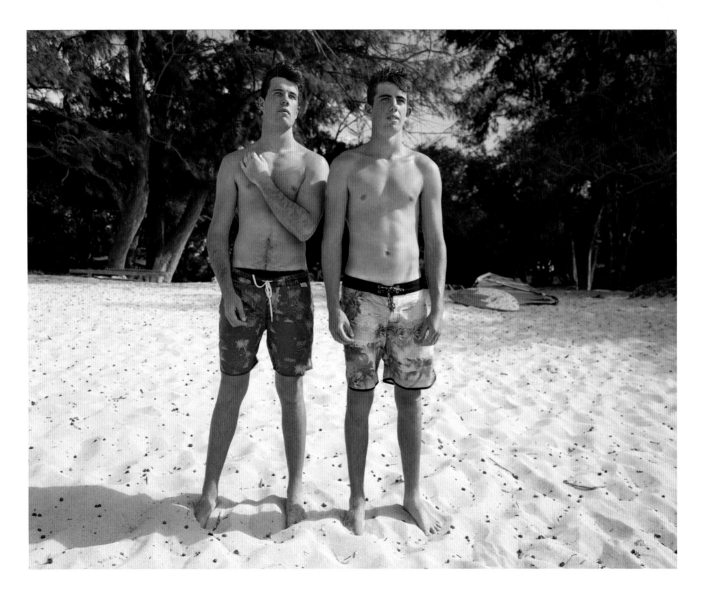

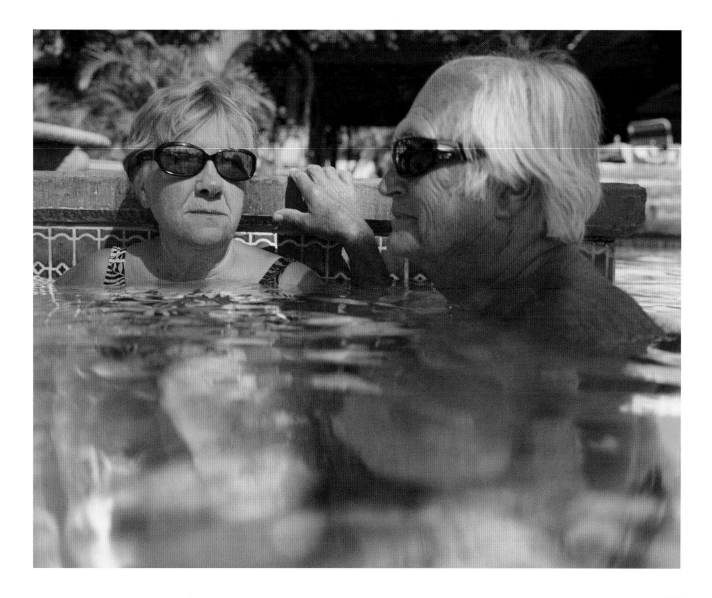

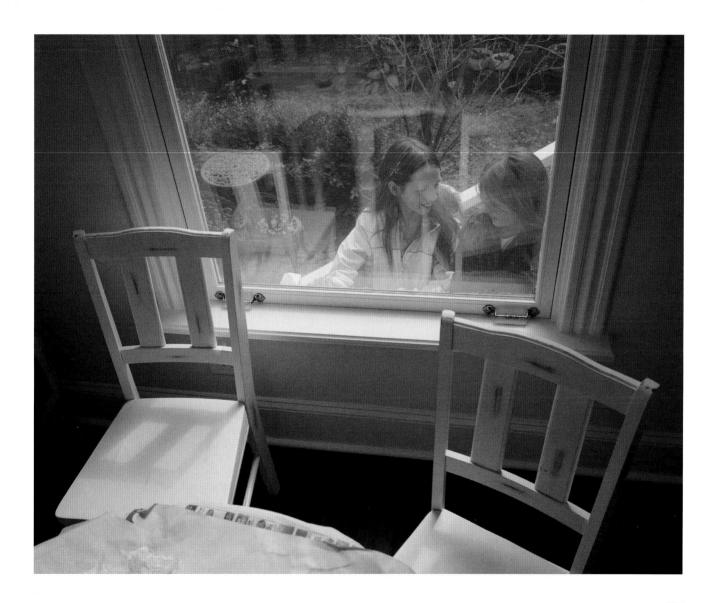

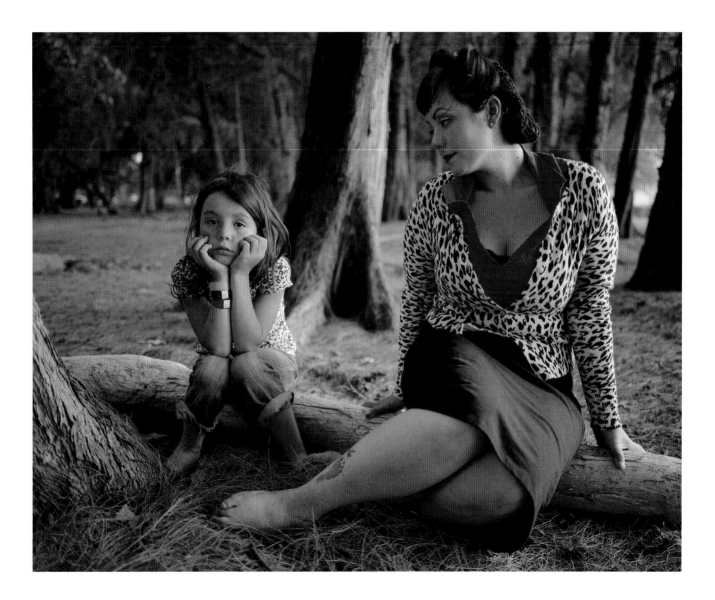

THEN ONe VanisheS

ALLAN GURGANUS

I.

"Two" is the loneliest number that you'll ever do.
"One" is one away from "two"
and post-subtraction, all that's left is "You."

think I was a twin. We lost Brother so early. Sometimes I still feel him behind me, our first comfy trimester. We swayed, basted equally in Mom's sweet saline. I remained the tense one, stringy, nearest the likely exit. He, far floppier, was apt to nod; he sure depended on me. But Brother Jesse had my back, literally. How did I know his gender in such darkness? Oh, I felt it there, the usual power-point indicator: disproportionate, optimistic, the trout of a guppy.

We'd grown near-onto-against each other. Each turn required treaty-scaled cooperation. I faced forward; his small arms slid under mine, support. Spooned against me, he had already become my church, my blue blanket, my Orville-Wilbur, the first monogamy and my last.

One morning he was gone. No resistance, only squishy margin. With Jesse missing, I was left forever after an open-face sandwich. If "two" is all you know, the joy of doubleness predates the act of eating, any appetite for oxygen, much less sex. He-me joined? A veritable pillow heaven. Now? my single topic is: us two, reduced.

Elvis Aaron Presley was, like me, a former always left-back twin. This pulled me even closer to our Tupelo boy. His brother, coincidentally, a "Jesse," too!

Jesse Garon Presley, also born January 9, 1935, arrived in daylight dead. Elvis came out clay-colored but, once butt-slapped, turned crimson while wailing. That second boy, unsung, stayed clay-gray. The kingly survivor, living an intensity far more than doubled, confessed his growing adult relation with a brother still invisible to others.

So, yes, I'm sure I was a twin. Don't you half-recall you might've started that way, too? It meant living hammocked in effortless rhyme. Some poets peddle mere romantic love. That's just discount twin-ness practiced on a genetic stranger! That's a handcuff afterthought compared to the subtle linkage joining me to Brother Jesse.

Even superb-fit partnerships dissolve too fast. I find that doctors have named my Jesse's desertion The Vanishing Twin Syndrome." (Go on, Google it. I'll wait here, I'm used to that.) Twenty percent of all twins die in their first trimester; 40 percent of triplets. The inaugural ultrasound might register multiple pulses. Then one heartbeat simply candle-snuffs; a body is reabsorbed. Jesse's exit? Silent, opaque paste. A mild discharge below, scarcely noted, unmourned even by our Mom.

My being born alone, as a Gemini, just teases me. And Mom's forever praised me as her "one-and-only." She's never believed my rumor of a roommate in the womb. "Son? Trust me. As the gatekeeper, I would've noticed." Was the late Jess better, gentler than I? Christ, yes.

So many of us considered "singles"—weren't, aren't. As comets have tails, we're all still ruddered by starter sibs' trace minerals. How much do I miss him? How long have you got? Grief that early shovel-shapes you—solely you—for a quest. I was "stood up" before I even quite unfolded. Whatever I have made of my adulthood, one act per day has been another little net I cast his way. I try and recollect all Jesse was becoming when he swam away without one parting back-pat. While I? Selfish, slept—as if for two.

II.

Famous Elvis's barber became his shrink and confidant. To that new employee, one Larry Geller, Elvis confided his dead twin's continuous company. Here I quote from Geller's fascinating blog-post of February 4, 2011 (www.elvispresleybiography.net/elvis-presley-hairstylist-larry-geller-blog):

"The life and death of his stillborn twin, Jesse Garon, was a precious mystery to Elvis…. [The first time I cut his hair] he told me that as a child he would talk about him to anyone who would listen. 'I have a brother!' he announced proudly, telling everyone how close they were, and how they talked together all the time. At night as he lay in his bed, in the dark and silence of his room, he would have special conversations with Jesse, and later tell people what his brother had said to him…."

"'I'll tell ya, Larry…we were in our mother's womb together, so why was he born dead and not me? He never even got his chance to live…why me? Why was I the one that was chosen? … I've always wondered what would've been if he had lived…. These kinds of questions tear my head up. There's got to be reasons for all this.

"'… Maybe, maybe it was something I did, ya know? … Maybe when we were in the womb together we were fighting like Jacob and his twin like it says in the Bible. Man, that story always stuck with me. Maybe I was like Jacob who tried to stop his brother from being born first. Hey, I'm just saying…anything's possible.'

"I learned so much about Elvis that first afternoon; his freedom of expression, his willingness to explore, and most of all his vulnerability. And in a curious way, the guys [Elvis's posse] were a composite of his twin—but never really a replacement.

"It wasn't until 1977, just a few months before Elvis's death, that I heard him bring up Jesse after all those years…. 'Lawrence,' Elvis declared excitedly, 'you won't believe the dream I just had. Man, it was so real. An' I can't remember dreaming about…Jesse Garon since I was a little kid. But there we were together—onstage. Seemed like thousands of people in the audience, and they were screaming at us. It was wild! We were dressed alike, wearing identical white jumpsuits, and we were both playing matching guitars slung around our shoulders. There were two blue spotlights, one shining on him, one on me. An' I kept looking at him, and, man, he was the spitting image of me.

"'I'll tell you something else, Lawrence …' Elvis grinned. 'Jesse had a way better voice than me.'"

III.

The frequency of Vanishing Twin Syndrome means: one-fifth of you reading this are secretly like me. You are the aggressive—and therefore deserted—twin. Don't you half-remember? Admit it.

Here's how you can truly know, and tonight. Complete this bedtime fall-asleep assignment: Once you're horizontal later, close those eyes as if you've never known there was a sun; draw your legs against your torso; wrap arms around those knees. Concentrate solely on your superior missing one. (Do not tell your sleeping partner who it is you're trying to reach, then hold. It can only make your beloved feel half-a-man, half-a-woman.) Now lift your own pillow. Place it either in front or behind you, wherever instinct hints that your missing one last snuggled. Curve against, protect, enjoy that fine damn pillow. Just feel your way a while.

Remember? You were two. Remember? You were not alone.

At first.

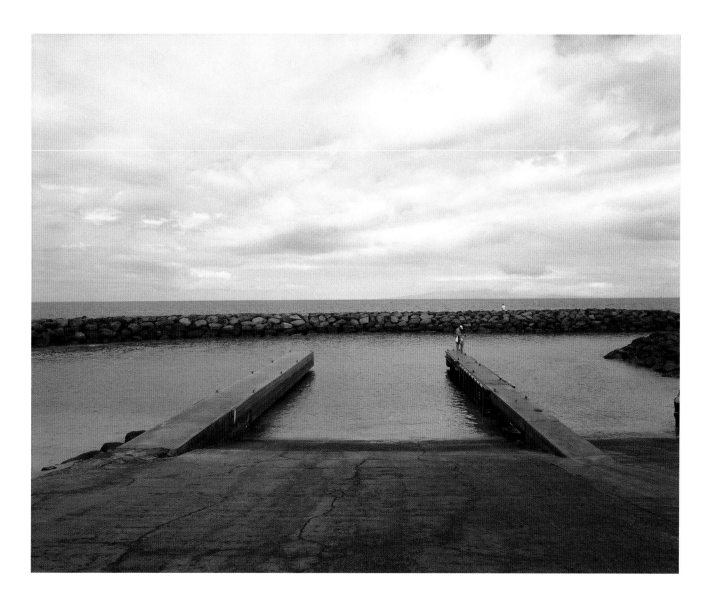

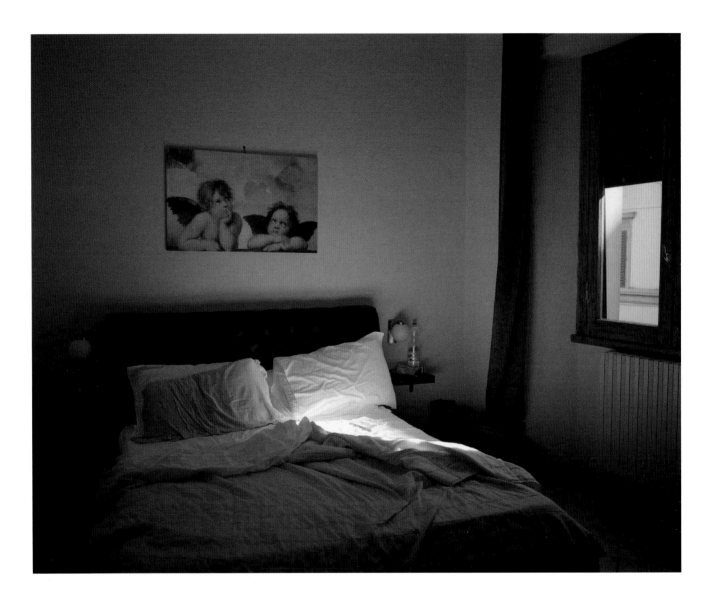

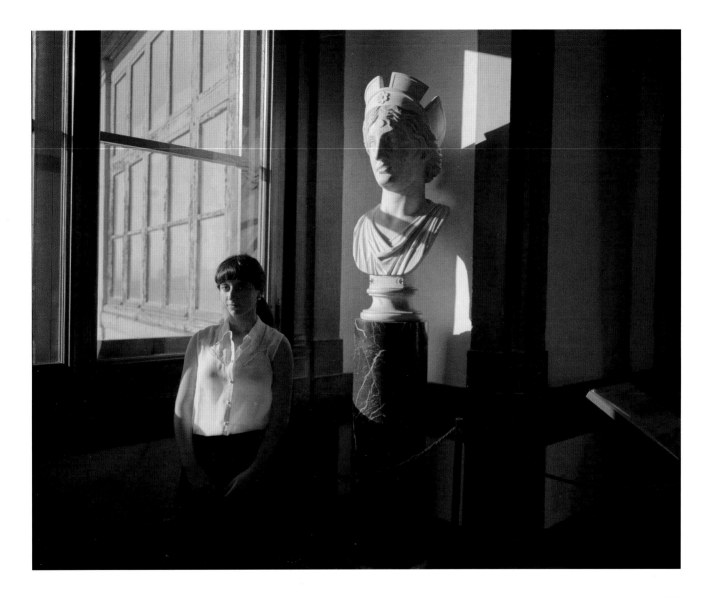

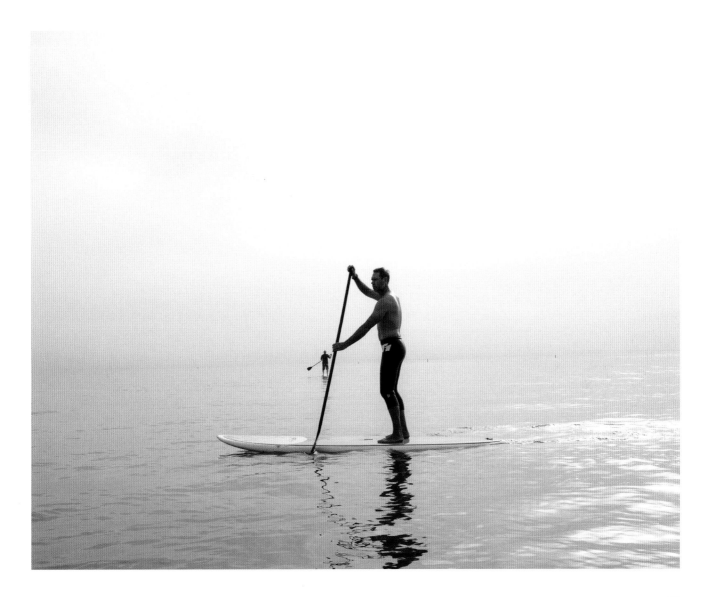

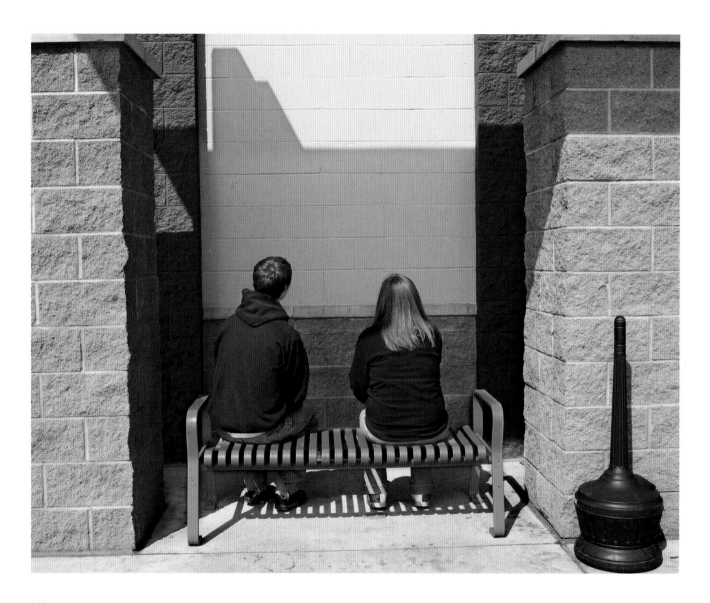

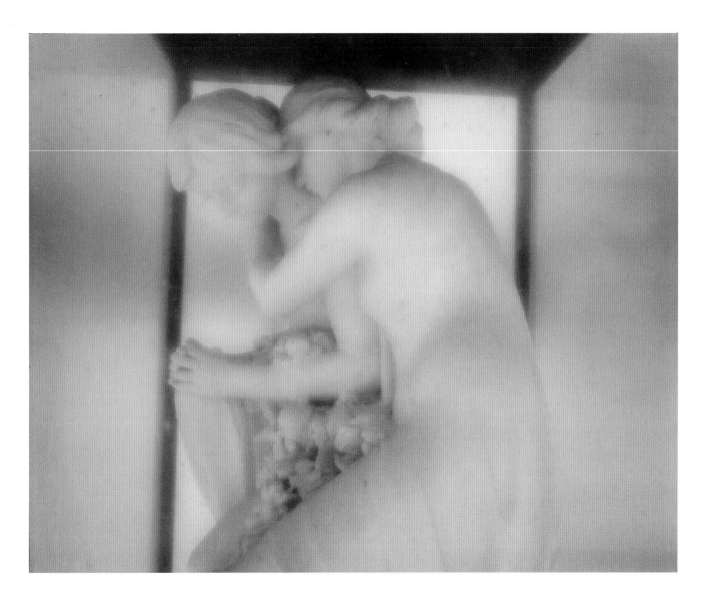

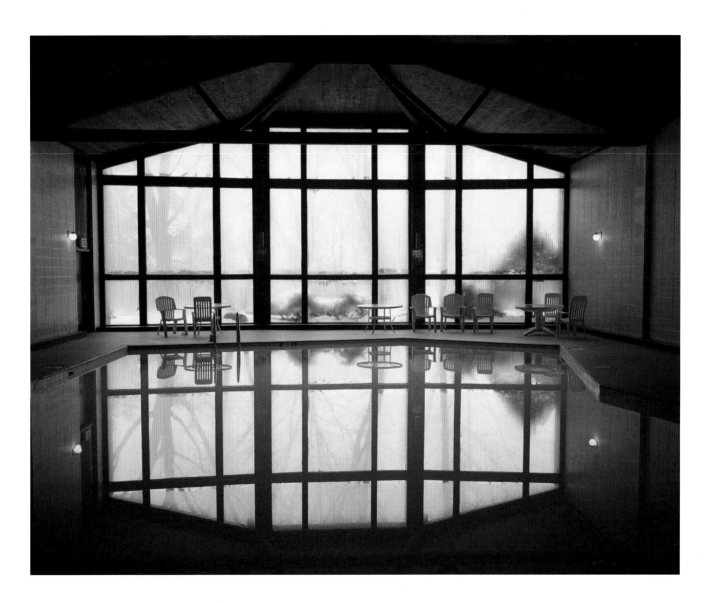

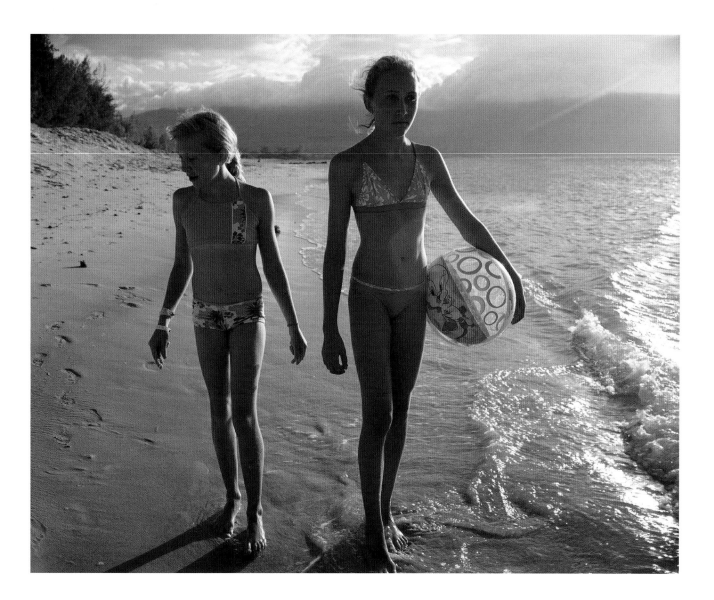

70 x 2

MAILE MELOY

My grandmother's father owned a grocery store in Windsor, Ontario, and like many small stores in the 1920s and 1930s, it had a rental library. Customers had to check books out, but no one monitored what my grandmother borrowed, and she read everything that came through. She used to climb a tree and sit in the yoke. She read *Lady Chatterley's Lover* there, in spite of the ban.

"Were you shocked?" I asked her.

"Oh, no," she said. "I had brothers, and they talked about everything."

In college in Detroit, she met my grandfather, who bought a car for twenty-five dollars so that he could offer her rides home. By 1942, he was a Marine Corps pilot, about to be sent to the Pacific. He sent her a telegram: "Come to California and we'll get married. Talk to your parents." She sent a reply saying yes, and then she told her family. She was nineteen, and he was

twenty-three. Her family said she was crazy: this flyboy was going to get killed, and then she would be twenty and pregnant and alone. His mother and her mother, in tears, saw her off at the train station.

But my grandmother always believed he would come back, and he did, from two tours of duty in World War II and another two in Korea. They had three small children by then, and she wrote angry letters to President Truman about not keeping his promise to bring the boys home. When my grandfather did come home, he retired a colonel, and then my grandparents had two more sons.

My grandmother was exceedingly pretty—in swimsuits at the beach and in dresses she made herself—and she still is. When people ask her how she manages it, she says, "I'm happy with the man I married." Sometimes they wake up at 3 AM and talk for an hour and a half before going back to sleep.

A few years ago, she started asking everyone in the family to choose something from their two-story house in Oregon. She put our names on sticky notes on the backs of paintings and the undersides of tables. I didn't want anything, mostly because I couldn't imagine a time when they wouldn't be living there. "You have to pick something," she told me. "We won't be here forever." And she was right: the stairs soon became too much work.

She started going through their things with dispatch. I got a message saying my name was on an end table; my brother's was on some prints that had been taken down from the wall. She was utterly unsentimental, shedding books and furniture as easily as she'd jettisoned her childhood to join the young pilot she'd decided to marry.

We talked on the phone, and she said, "It's crazy, they do this thing now called *setting* the house."

"You mean staging?"

"Staging!" she said. "Have you ever heard of such a thing?"

I had. I wasn't able to picture my grandparents' house staged.

But soon it was, and a friend told my grandmother that the built-in shelves looked fabulous, with a vase, a bowl, an Indonesian basket, lots of empty space, a few books artfully arranged. "Why didn't you always have it this way?" the friend asked.

"Because it was a bookcase!" she said. "It was a functioning bookcase!"

The house sold, and my grandparents moved into a condo complex for people fifty-five and older. They were forty years over the qualifying age. "It's not for long," my grandfather told me. "What do we have—two years, three?" But they have a new great-grandson and a newer great-granddaughter on the way, and both have piqued my grandmother's interest. "I tell the Lord I'm not ready to go," she says. "Not yet."

They don't have their own yard anymore, or plants to water, or bird seed to lock away from marauding bears. They've had to learn a new routine, and for about a week I thought a small dog might provide one, so I scanned the local animal shelter websites. But they've settled in now, and they don't need a dog. The new place has a gym, a pool, a dining hall with good food, a park with a creek. It has a lending library, although I don't see my grandmother climbing any trees with her paperbacks. "All the doors open with a button!" my grandfather said when I was last there. "Everything is a button!"

He e-mails me from his new desk, but my grandmother won't. "I can't learn that stuff," she says. "I don't want to learn that stuff!" She asks, "Can you imagine how everything has changed?"—this woman who was summoned by telegram and railroad across the country to her new life.

For their seventieth wedding anniversary, they didn't want a party. They spent the weekend going to their favorite restaurants and to a play. The new condo has all the furniture they need: a sofa and two chairs in the living room, two recliners for the TV in my grandfather's office, the pictures of children and grandchildren and great-grandchildren on the bedroom wall. What has mattered, always, is that they're together, and everything else falls away.

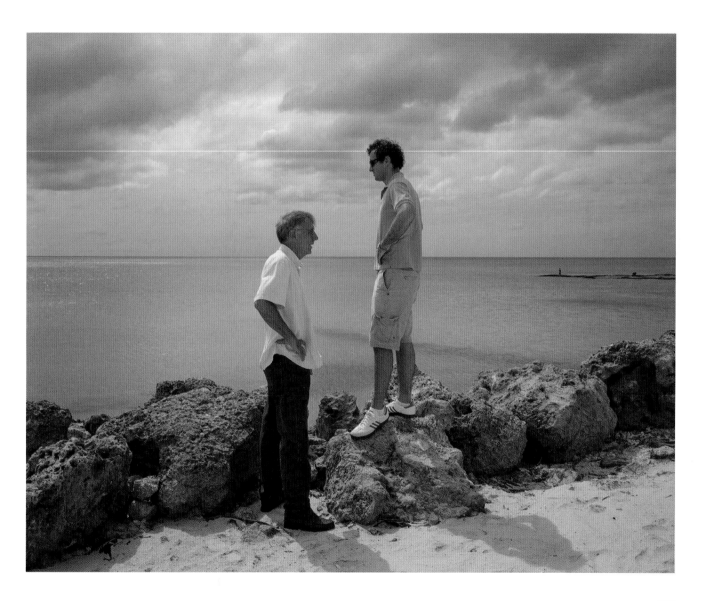

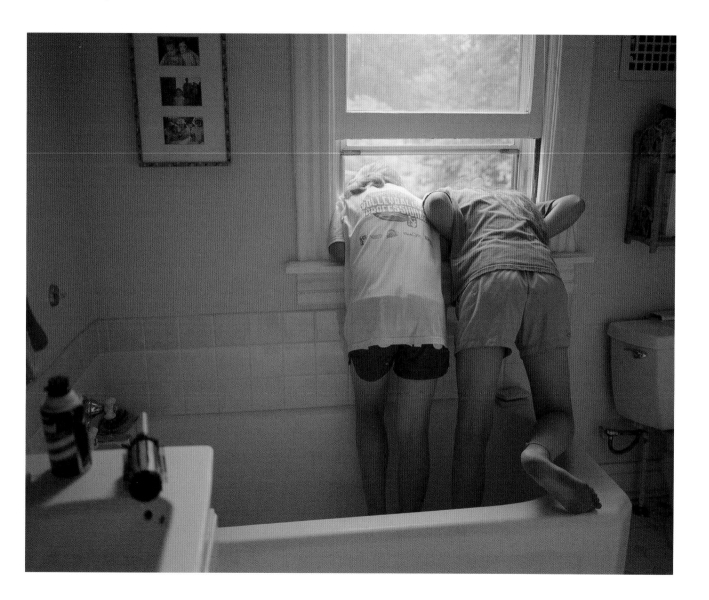

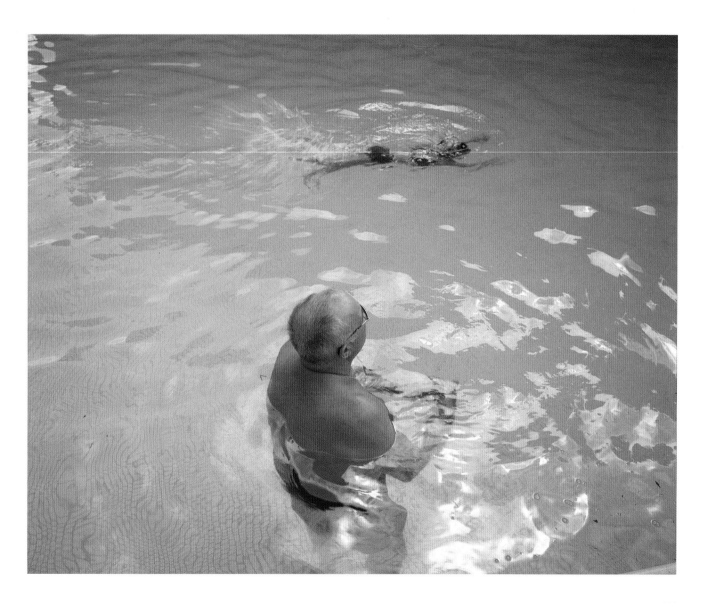

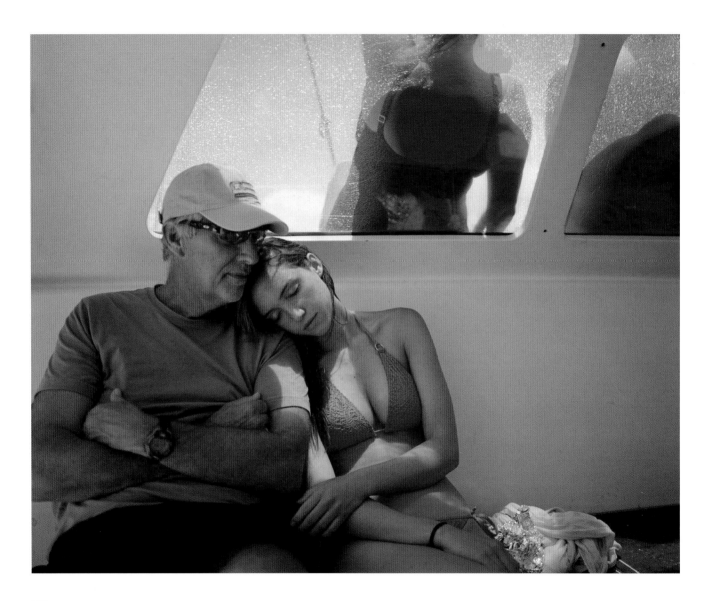

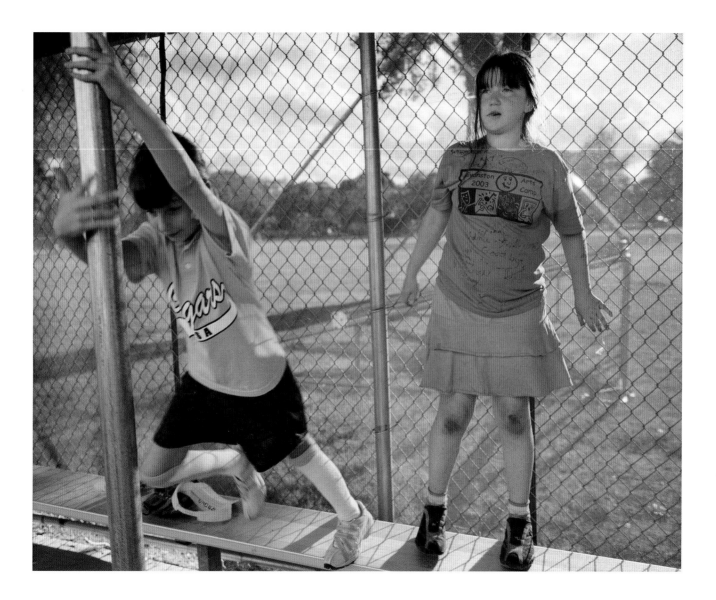

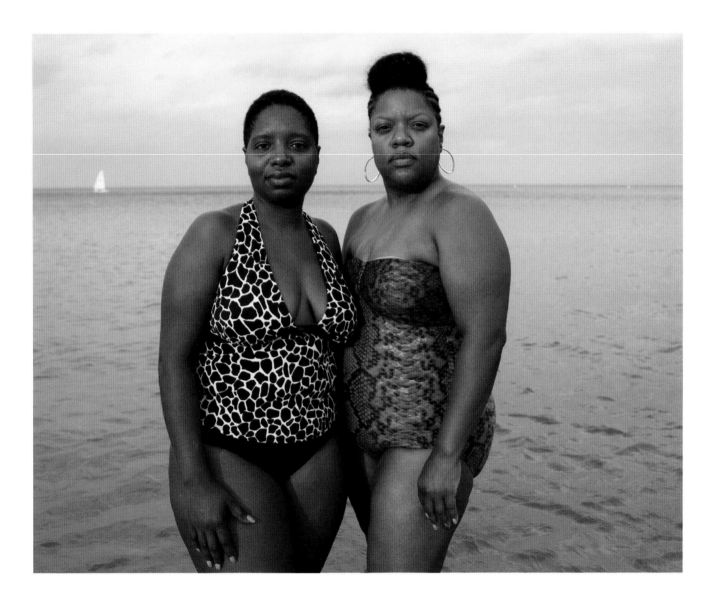

THE DOLLIES

ELIZABETH McCRACKEN

In childhood photographs they are the most fraternal of fraternal twin sisters. My mother's hair is dark and wild, her enormous brown eyes amused. My aunt is blond, hazel-eyed, delicate, taller. They don't even look like sisters, really. The Dollies, their baby nurse called them. Eventually my aunt's hair darkened to chestnut, and for a while they looked more alike, though now my mother's hair is silver, and still wild, and her sister wears a careful ponytail down her back.

My mother loved being a twin, but her twin, she always told me, hated it. To be a twin, my mother felt, meant being special: to be double was singular. She was three minutes older. Those three minutes still mean something, though the Dollies are now nearly eighty.

"Well," my mother says, "she had a bossy big sister and I didn't."

That's what twinhood always meant to me: never matching at all. It was as though the Dollies had, in childhood, reached into the sack of interests and skills and attitudes, and divvied them up. My mother got math, grammar, and extroversion. My aunt got art, music, shyness. They

were so positive about this—my mother could only draw slices of watermelons and the backs of rabbits, and explained this was because my aunt was such an excellent artist—that growing up I believed that it was a law of genetics. If you were twins, you *couldn't* be alike. You had to share. Better to take all of math and forgo music than to be only so-so at both. Better to love public speaking and understand you would never be able to carry a tune. That made sense to me. Who would want to be only average at anything?

My mother wants a souvenir of anything she loves: the playbill, the mug, the family jewelry, the flea market tchotchke that reminds her of her childhood. My aunt has a favorite Goodwill donation box and visits it often. My mother loves to travel, my aunt is a homebody; my mother loves novelty, my aunt routine. My mother doesn't dwell on the sadness of the past, ever. My aunt says she has *in utero* memories: my mother took up more room.

They love each other.

Nothing uncanny. No secret language or psychic connection. For instance: my aunt insists my mother is wrong, she never hated being a twin. "I came into the world with her!" she says, shocked at the idea her sister would repudiate the state of twin-ness, and then, "It goes to show you: don't take the twin's word without checking with the *real* person."

My optimistic mother is disappointed by few things, but she was genuinely sad when the doctors who'd listened to her mid-1960s pregnancies and palpated and guessed—back in the days when medical science couldn't fully intrude on the privacy of the fetus—turned out to be wrong: no twins, either time, just one lousy baby (my brother) and then another (me). She'd believed those doctors; she'd been thrilled. She felt she'd been *promised*. "The only people who weren't

excited about me having twins were my mother and my twin sister," she says. "I thought that was insulting." She consoled herself: twins run in families, she could hope for twin grandchildren. That didn't work out either.

"Are you twins?" my mother says to twinnish children on the street. "I'm a twin, too."

The world is awash in twins these days—with fertility treatments, and older mothers (advanced maternal age being one of the—I don't dare say *risks*, since that sounds negative—one of the *contributing* factors for twins). "We both think those twins are *fake* twins," my mother says, only sort of joking. "We liked being a rarity."

Their parents are dead, their husbands are dead. They haven't been in the same room for a few years, but they talk several times a day on the phone. Who needs a psychic connection in a world with cheap cell phone service? When they were little, my aunt sometimes told my mother she couldn't sleep until her bossy big sister told her to. These days it isn't sometimes, it's always.

"Sleep tight," my mother says from Boston, every night of the world, and so my aunt, in Saint Louis, obeys, and goes to sleep.

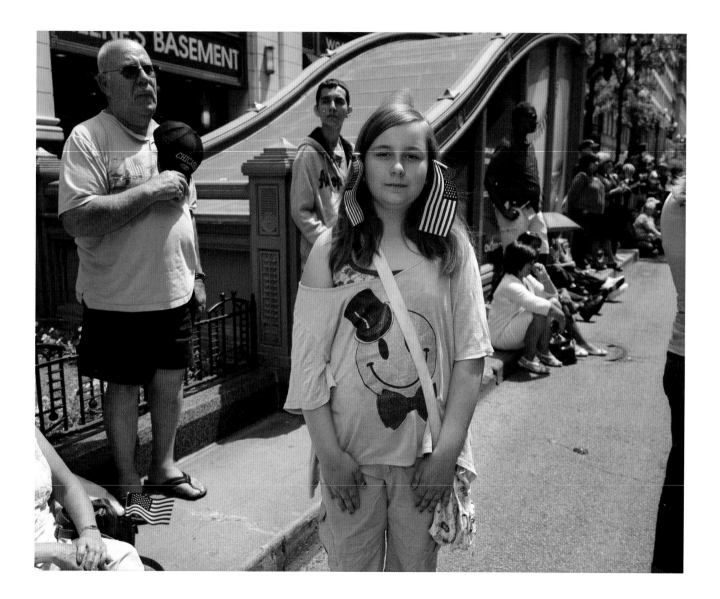

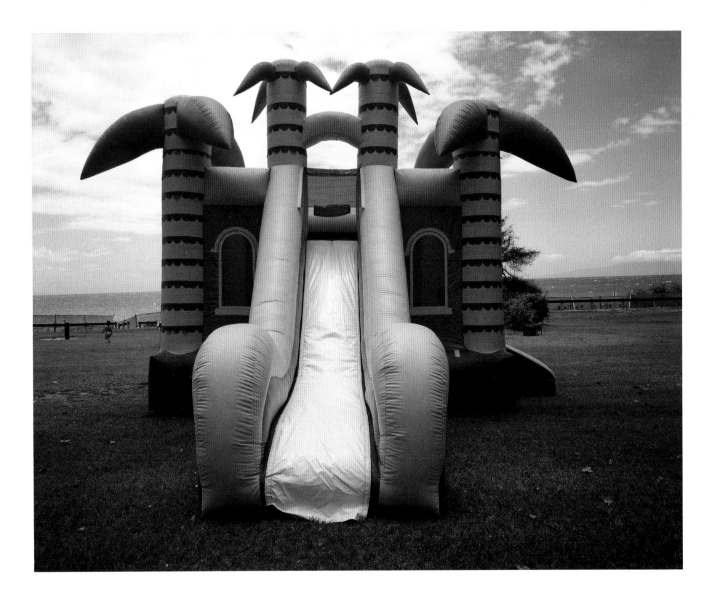

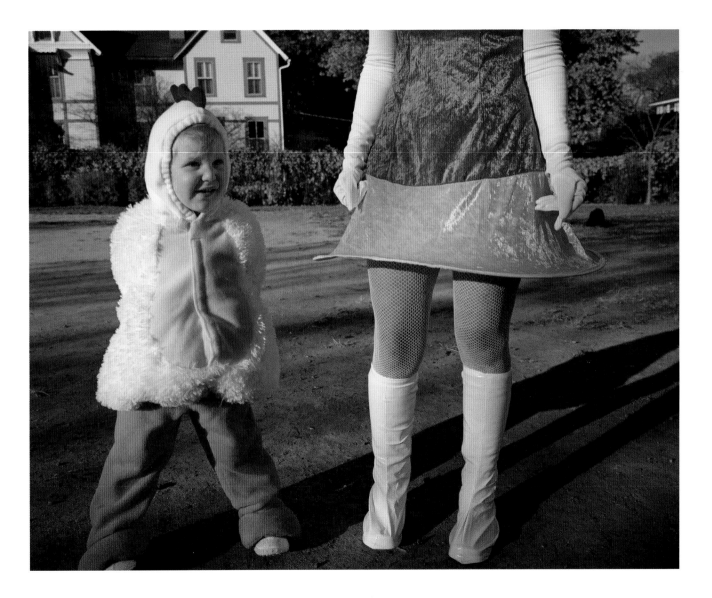

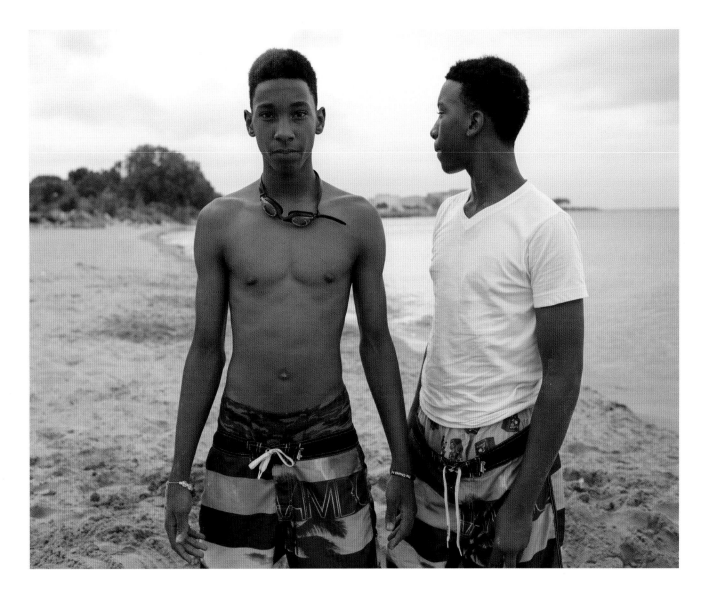

22

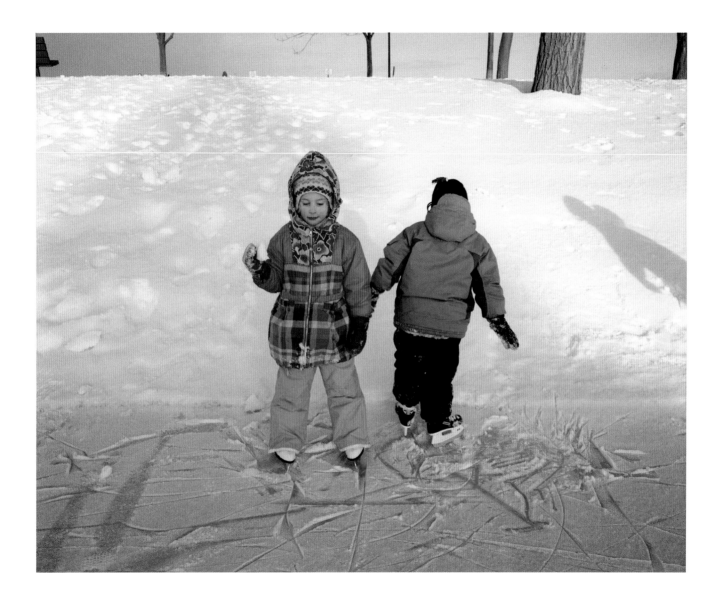

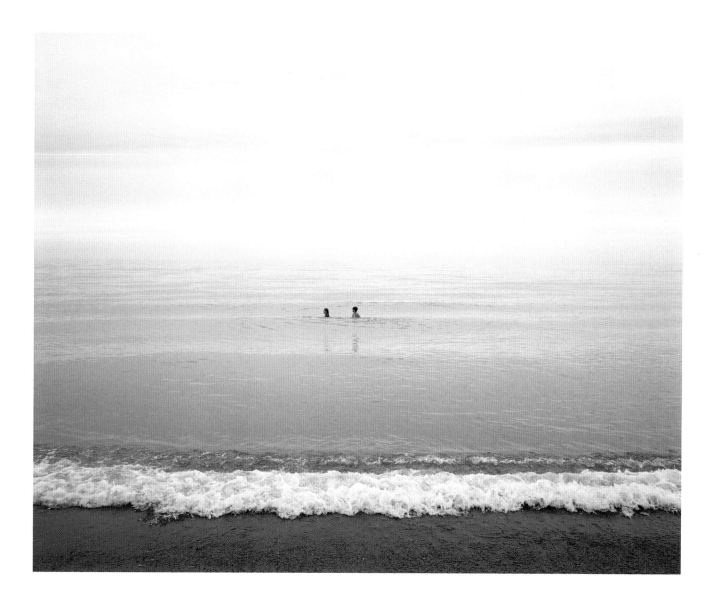

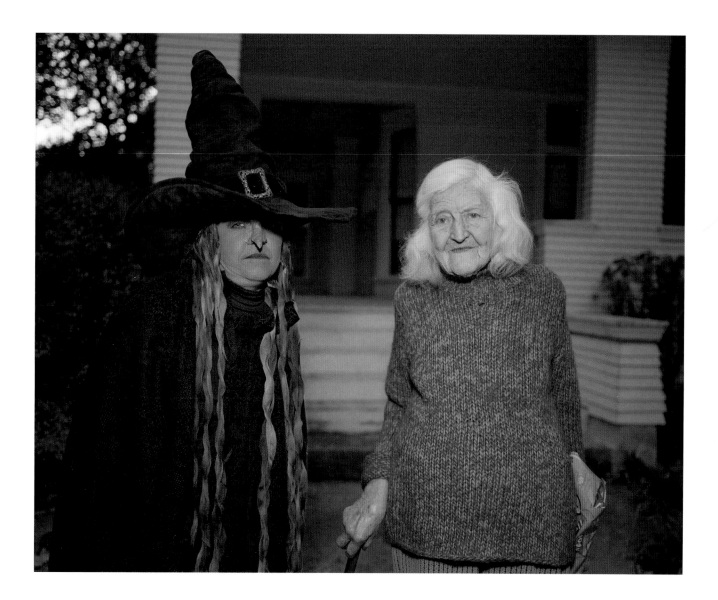

AREN'T WE A PAIR

JANE HAMILTON

Oak Park, Illinois. 1967. Two ten-year-old girls. One is the color of dark toast not yet burned. Elzena. The other actually is burned, her pink skin blistered and peeling. Jane. I am a girl with a standard name.

Elzena and I are the same height, there is that. We both have brown eyes and are skinny, our elbows sharp, our knees knobby. Our teeth are big and white and square. It could be said that our hair is the same color, although the very substance, it seems, could not be more different.

Someone with the best intentions at the Jane Addams Hull House Association has dreamed up a project wherein suburban families host a ghetto child for a two-week summer session. My mother signs on, requesting a girl my age. "Aren't you a pair!" the neighbor woman enthuses when Elzena arrives.

It's as if being two confers upon us an immediate sameness, as if being the same age insures friendship; sameness and friendship, apparently, a matter of numbers, of math.

Elzena lives in a tenement on the South Side. It turns out that tenements are not fictional buildings in books. There is no forgetting the trip to pick her up, the bare lightbulb hanging as if by a thread in the fifth-floor hallway right by the bathroom door, the bathroom many families share. Everything is cracked: the dirty windows, the linoleum, the walls, the scuffed stairs, and probably the one toilet. There is a smell. Chicago's pride, Jane Addams, found her life's work at a young age when her father drove her through the ghetto: she would minister to the poor and build a settlement house. Standing in the tenement hallway I resist any such calling. Elzena's mother, a stringy, gap-toothed woman with a baby on her hip, seems leery of us, even as she nudges Elzena out the door.

We drive to Wisconsin, to my grandmother's lake house. When Elzena is getting out of the car someone slams the door on her hand. I've never seen anyone react to pain with such violence and also despair. There's no way to comfort the girl who's screaming, holding her hand, doubling over into herself, rising up howling before doubling over again. There's the trip to the emergency room, and following that, candy. For the next few days she sits on the pier in her pink two-piece bathing suit, an enormous white bandage, a mitt on her hand, and watches the cousins swim. We don't seem to interest her much. She does not, however, ask to go home. She'd wanted her mother at first, but maybe she stopped asking because she understood she was a prisoner in paradise. Nothing to do but wait it out.

Back home in Oak Park, we share the sleeping porch, the cicadas and birds in the green world right past the screens. She has brought a stash of Barbies, a lot of dolls for a poor person, I think. She

also has quite a bit of cash, from her church, she tells me, far more money than I've ever seen. I wonder how she'll spend it, what she'll buy for the tenement. Always, the tenement is in my mind.

After her bandage comes off we go to the public pool. There aren't many African Americans in Oak Park at that point, but we are a polite community. The adults smile brightly and the children are told not to stare. We spend the week in a stupor, Elzena and I, waiting, waiting for our twin stint to end.

Even at the time I wonder, What is the point of this exercise? Am I supposed to inspire her with my library books and piano playing? Will she want to do well in school so she might someday live in a suburb? If you so much as see possibility, are you automatically lifted up? This seems doubtful, the splintered tenement darkly shining out past the green world. She'll go home and if she doesn't still have pain in her hand, she'll have thought it was all a dream. Are we supposed to keep in touch, become pen pals, so that along the way my parents can offer assistance? Maybe, I later think, the project was meant to make my older siblings and me develop a social conscience; maybe the scheme was really only for us.

For a while my mother no doubt communicates with the family, but when Elzena is gone I do my best not to think about her. So that now, forty-seven years later, Elzena is still that brave, lonesome girl at the mercy of our charity. I do remember one night when it's possible we forgot ourselves, forgot our misery. We'd put on my older sisters' tutus. That's the moment to preserve: two girls, that's all we are, two skinny ten-year-olds in pink tulle, a pair, dancing.

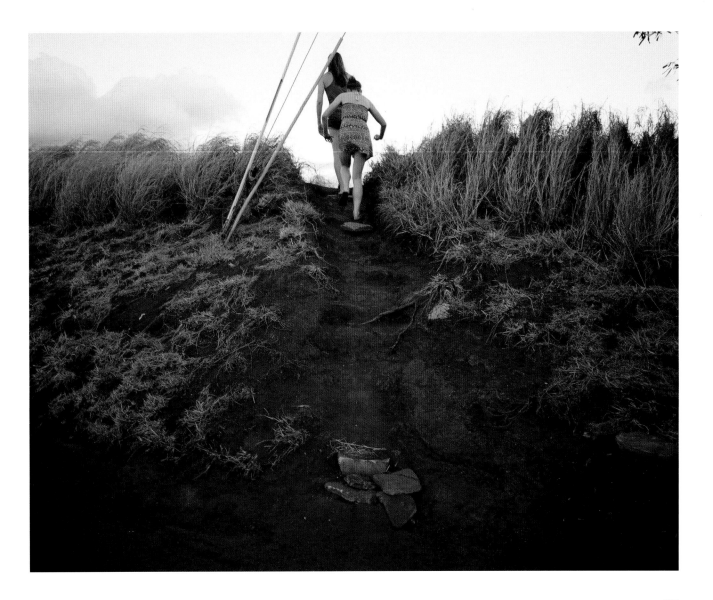

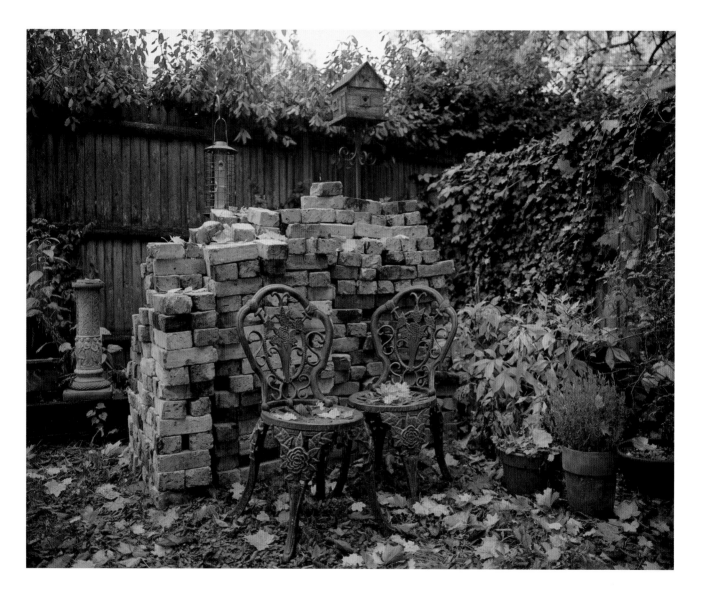

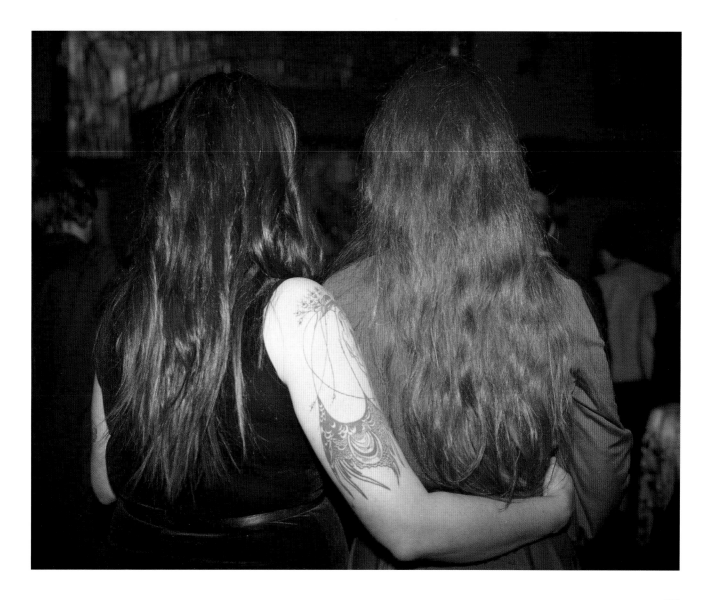

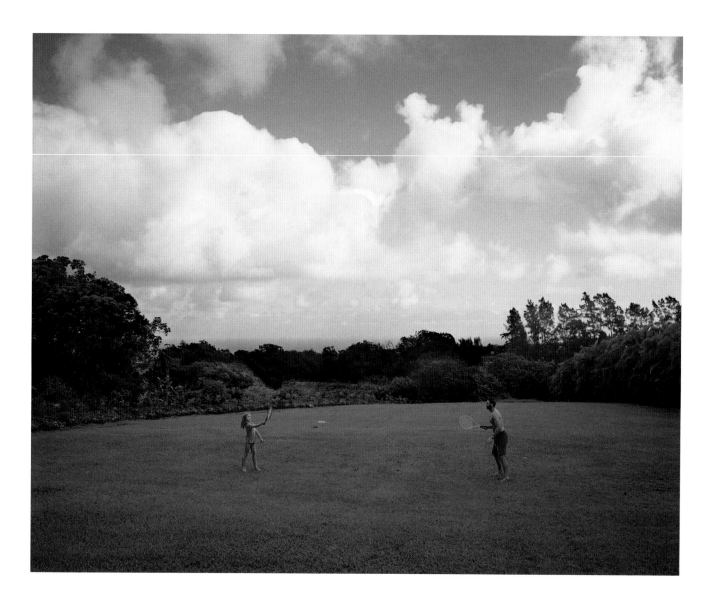

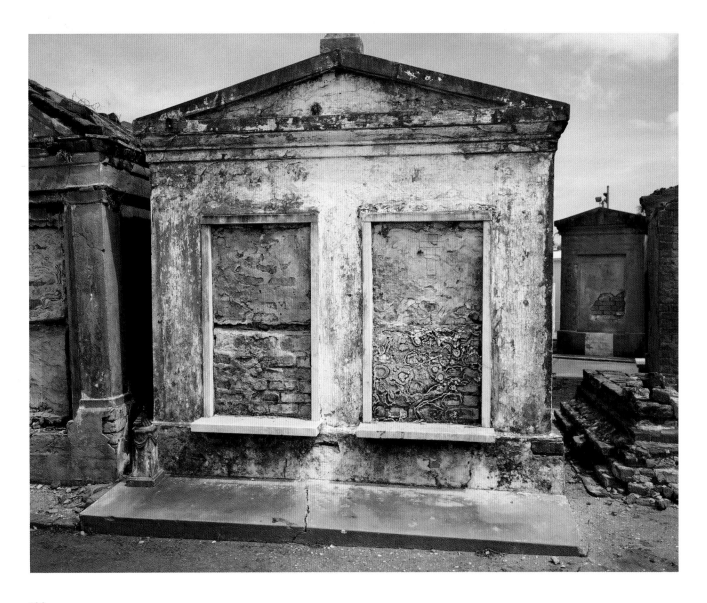

196

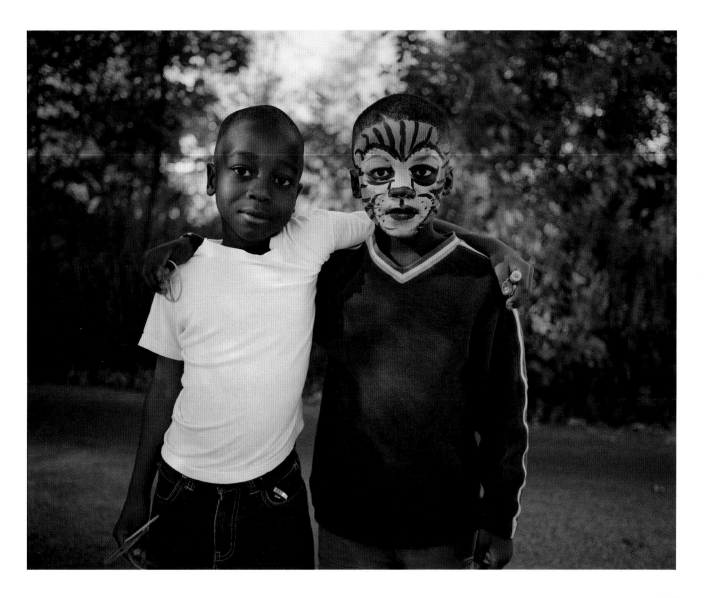

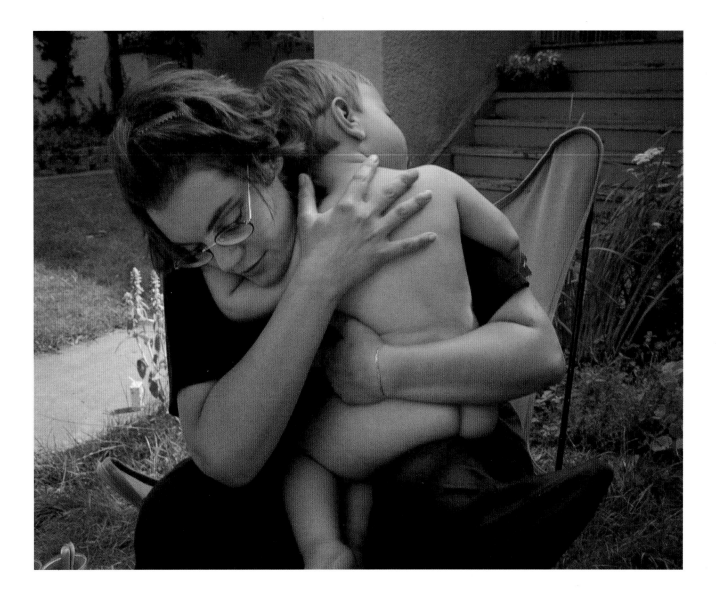

APPENDICES

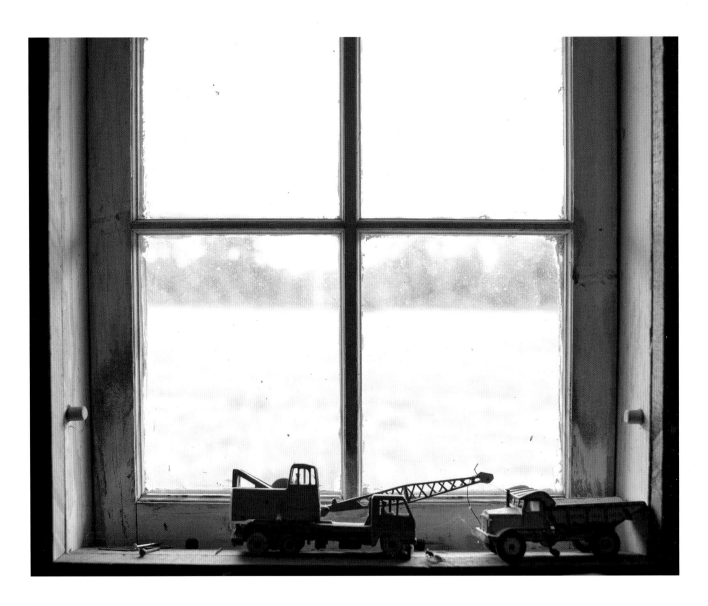

LIST OF PLATES

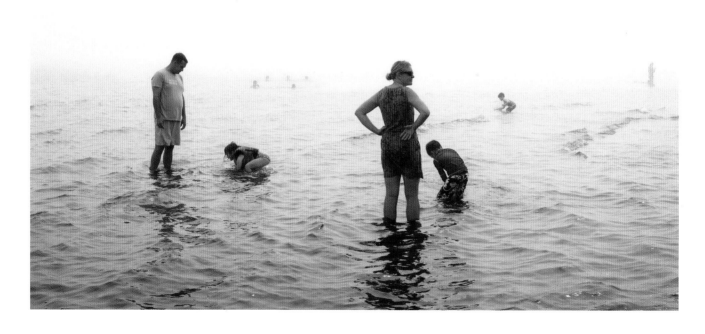

204

ACKNOWLEDGMENTS

Two would not exist without Ann Patchett. I thank Ann for her unflagging enthusiasm, support, and invaluable guidance through the making of this book. I am also grateful for the opportunity *Two* has given me to present my photography in new ways. It has been a tremendous gift.

Thank you to each of the distinguished writers who so generously contributed their work to this book: Billy Collins, Edwidge Danticat, Elizabeth Gilbert, Allan Gurganus, Jane Hamilton, Barbara Kingsolver, Elizabeth McCracken, Maile Meloy, Susan Orlean, and Richard Russo. I am honored by your participation.

Thank you to those who shared their insight and time with me. Rebecca Stepler was indispensable from the beginning. Many thanks to Karen Buckley, Paul D'Amato, Mary Dougherty, Kristen Gresh, Karen Haas, Greg Harris, Anne Havinga, Karsten Lund, Eileen Madden, Vicky Pinney, Colleen Plumb, Justin Schmitz, Carrie Springer, Doug Stapleton, Barbara Tannenbaum, Bob Thall, David Travis, Susan Weininger, Jay Wolke, and my assistant, Abby Tebeau. Thank you to Walker Blackwell and Tom Dryjanski of Latitude Chicago. Many thanks to Jonathan Burnham, Elizabeth Viscott Sullivan, and Lynne Yeamans at HarperCollins, and to Lisa Bankoff, John DeLaney, and Daniel Kirschen at ICM.

I am forever indebted to my dearest friends and fellow artists, the late Kate Friedman and the late Peter Hales.

Thank you to my husband, Roger, and to our daughter, Emma—my special two.

Melissa Ann Pinney is the author of *Regarding Emma: Photographs of American Women and Girls* and *Girl Ascending*. She was awarded a Guggenheim Fellowship. Her photographs are included in the permanent collections of many museums, including the Metropolitan Museum of Art, the Museum of Modern Art, the Whitney Museum of American Art, the Art Institute of Chicago, the International Center of Photography, the George Eastman House, and the J. Paul Getty Museum. She lives in Evanston, Illinois. www.melissaannpinney.com.

ABOUT THE EDITOR

Ann Patchett is the author of six novels and three books of nonfiction. She has won many prizes, including Britain's Orange Prize, the PEN/Faulkner Prize, and the Book Sense Book of the Year. Her work has been translated into more than thirty languages. She lives in Nashville, Tennessee, where she is the co-owner of Parnassus Books.

ABOUT THE CONTRIBUTORS

Billy Collins's latest collection of poems is *Aimless Love: New and Selected Poems*. He is a Distinguished Professor at Lehman College (CUNY) and a Senior Distinguished Fellow of the Winter Park Institute at Rollins College. He served as United States Poet Laureate (2001–2003) and New York State Poet (2004–2006). He is also a New York Public Library "Literary Lion."

Edwidge Danticat is the author of several books, including *Breath*, *Eyes*, *Memory*; *Krik? Krak!*; and *The Dew Breaker*. She is also the editor of *Haiti Noir* and *Haiti Noir 2*. She has written four books for young adults and children (*Anacaona*, *Golden Flower*; *Behind the Mountains*; *Eight Days: A Story of Haiti*); and *The Last Mapou* as well as a travel narrative, *After the Dance: A Walk Through Carnival in Jacmel, Haiti*. Her memoir, *Brother, I'm Dying*, was a 2007 finalist for the National Book Award and a 2008 winner of the National Book Critics Circle Award for autobiography. Her most recent book is *Claire of the Sea Light*.

Elizabeth Gilbert is the author of six works of fiction and nonfiction, including the memoir *Eat, Pray, Love*. Her work has been nominated for the PEN/Hemingway Award, the National Book Award, and the National Book Critics Circle Award. Her most recent novel, *The Signature of All Things*, was named as a best book of 2013 by the *New York Times*, *The New Yorker*, *Time*, *O Magazine*, and the *Washington Post*. She lives in New Jersey.

Allan Gurganus is a novelist and story writer. His books include *Oldest Living Confederate Widow Tells All*, *White People*, *Plays Well with Others*, *The Practical Heart*, and *Local Souls*. A member of the American Academy of Arts and Letters, he has won the Los Angeles Times Book Prize and the American Magazine Prize. His stories have been published in *Best American Stories*, *The O'Henry Prize Stories*, and *The Norton Anthology of Short Fiction*. A recent Guggenheim fellow, he is at work on a novel, *The Erotic History of a Country Baptist Church*. He lives in his native North Carolina.

Jane Hamilton has written six novels including *The Book of Ruth* and *A Map of the World*. Her essays and stories have appeared in *Harper's*, the *New York Times*, and various anthologies. She's won awards for her work, had the lightning strike of Oprah's Book Club twice, and has taught in the Warren Wilson MFA Program. She lives on an apple farm in Wisconsin with her husband.

Barbara Kingsolver's fourteen books of fiction, poetry, and creative nonfiction include the novels *The Bean Trees*, *The Poisonwood Bible*, and *The Lacuna*. Translated into more than twenty languages, her work has won a devoted worldwide readership, a place in the core English literature curriculum, and many awards, including the National Humanities Medal. Her fiction has been three times shortlisted and one time a winner of Britain's Orange Prize. She has two daughters, and has lived on a farm in southern Appalachia with her husband, Steven Hopp, since 2004.

Elizabeth McCracken is the author of *Here's Your Hat What's Your Hurry*, *The Giant's House*, *Niagara Falls All Over Again*, *An Exact Replica of a Figment of My Imagination*, and *Thunderstruck & Other Stories*. She's received grants and fellowships from the Guggenheim Foundation, the National Endowment for the Arts, the Liguria Study Center, the American Academy in Berlin, the Fine Arts Work Center in Provincetown, and the Radcliffe Institute for Advanced Study. She presently holds the James A. Michener Chair in Fiction at the University of Texas, Austin.

Maile Meloy is the author of two novels, two young adult novels, and two story collections. The most recent collection, *Both Ways Is the Only Way I Want It*, was one of the *New York Times Book Review*'s Ten Best Books of 2009. She has won the PEN/Malamud Award and the E. B. White Award, and was one of *Granta*'s Best Young American Novelists. Her stories have been published in *The New Yorker* and the *Paris Review*.

Susan Orlean is the author of eight books, including *Rin Tin Tin: The Life and the Legend* and *The Orchid Thief*. She has been a staff writer at *The New Yorker* since 1992. In 2014, she was awarded a Guggenheim Fellowship in Creative Arts. She lives with her husband, son, and an assortment of animals in the Hudson Valley of New York and in Los Angeles.

Richard Russo is an award-winning novelist and screenwriter who is the author of seven novels and two short story collections. *Empire Falls* won the Pulitzer Prize for fiction in 2002. His most recent book is the memoir *Elsewhere*. He lives with his wife in Portland, Maine.